1992
Christmas
With Love Joy
AND Best wishes xx

Louise + Des

Cofion Cynnes
i flwyddyn newydd ddg

The HALF-HOUR PAINTER

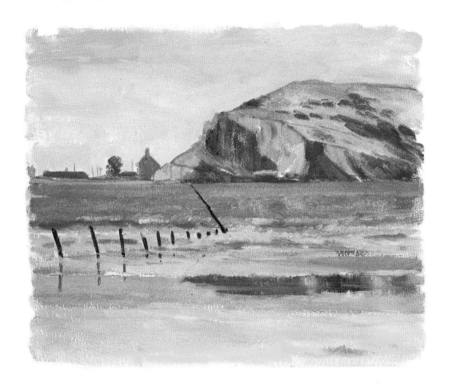

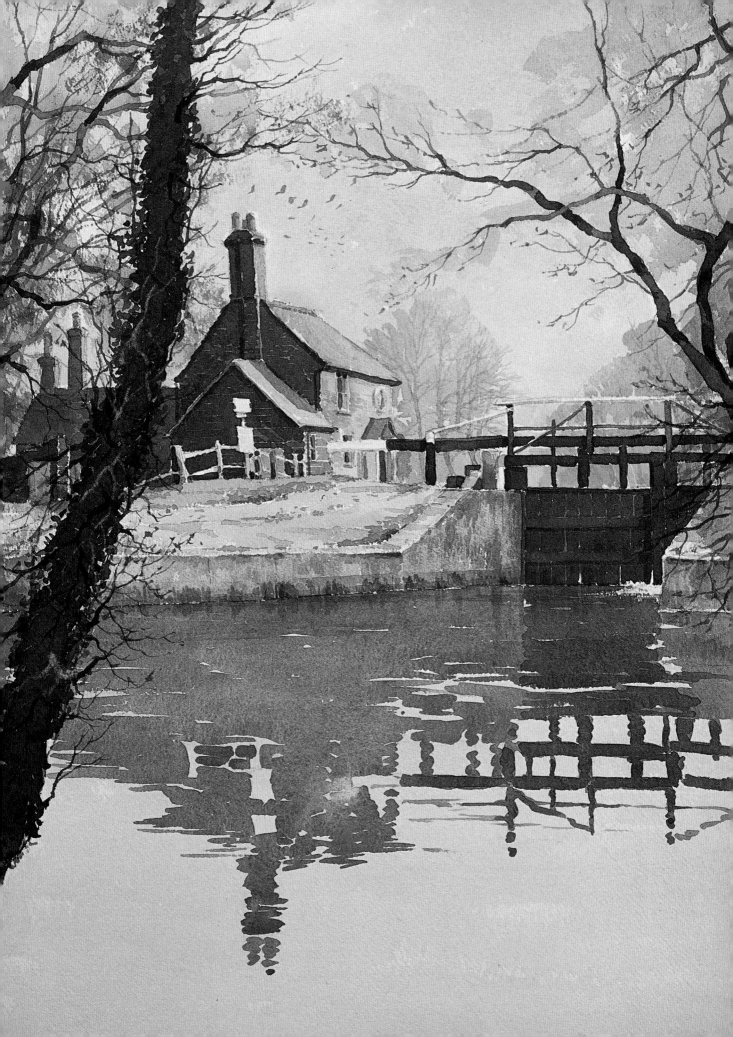

The
HALF-HOUR
PAINTER

PAINT A SUCCESSFUL LANDSCAPE IN 30 MINUTES

Alwyn Crawshaw

COLLINS

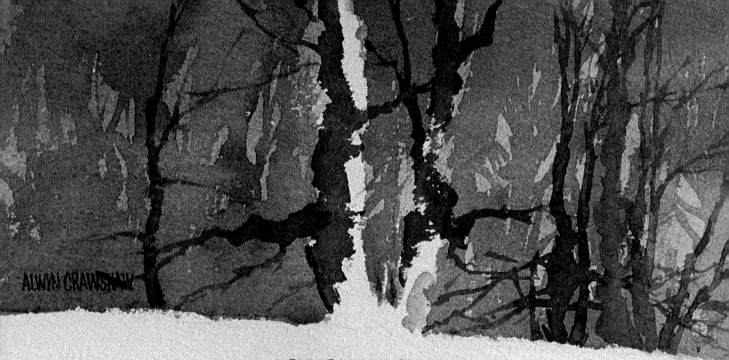

ACKNOWLEDGEMENTS

I should like to express my thanks to my
daughter and son-in-law Donna and Andy
Goolding for looking after June and me on
our Wales trip, and Audrey and Colin
Whittle for being our perfect hosts in the
Lake District; Collins, and in particular Joan
Clibbon and Cathy Gosling; Trevor Spooner
for designing the book, Joan Field for editing,
and Gertrude Young for typing the
manuscript. Finally, my wife June for her
patience and understanding and her
welcome participation in this book.

The Travelling Studio is obtainable from Daler-Rowney
stockists or direct from the manufacturers:
Teaching Art Ltd., Westborough, Newark, Notts. NG23 5HJ, UK.

First published in 1989
by William Collins Sons & Co Ltd
London · Glasgow · Sydney
Auckland · Toronto · Johannesburg
Reprinted 1989, 1990

© Alwyn Crawshaw, 1989

Designed by Trevor Spooner
Edited by Joan Field
Photography by Nigel Cheffers-Heard
Phototypeset by Southern Positives and Negatives (SPAN)
Colour reproduction by C.S. Graphics Pte Ltd

British Library Cataloguing in Publication Data
 Crawshaw, Alwyn
 The half-hour painter.
 1. Landscape paintings. Techniques
 I. Title
 751.4

 ISBN 0 00 412426 X

Printed and bound in Singapore
by C.S. Graphics Pte Ltd

A new snow fall. *Watercolour on Whatman 200 lb Not, 38×51 cm (15×20 in)*

CONTENTS

INTRODUCTION

Over the years, I have found that most students have great difficulty in learning to paint a picture as a whole, in a broad statement, before putting in any detail.

One of the best ways to overcome this problem is to practise half-hour exercises, so let us see how they can help.

Observation A vital stage further than just looking at a scene or object, observation is the very foundation of all painting. Suppose you were going to paint a harbour scene and you saw there a boat painted blue. If you took time to look very carefully (observe) you would notice that the boat is resting at an angle; someone on the deck, half-hidden by the wheelhouse, is mending a net; a shadow is cast over the stern of the boat by the building on the quay; and so on.

If you regularly practise half-hour exercises your observation skill will be sharpened so that, in time, it will become automatic.

To paint we have to look but, more important, we have to observe.

Simplification It is impossible to paint a scene and include everything that nature offers. We couldn't paint every blade of grass in a field, so we have to simplify it. By practising half-hour exercises you will train yourself to go for broad shapes – and to stop fiddling with a small brush, particularly at the beginning of a painting. Look for and simplify the main characteristics, eliminating any unnecessary detail, and your painting will capture the feeling and look of the scene.

We must simplify nature in order to paint it.

Form and shape Objects can be seen because light falls on parts of them, forming shadows on other parts. Light against dark – dark against light. Naturally, there are tones in between, but if you screw up your eyes and look at an object, you see only the darks and lights. This enables you to pick out forms and shapes and see them in their tonal values. By carefully observing form and shape in a half-hour exercise you are training yourself in a quick controlled way.

Form and shape are seen because objects are light against dark, or dark against light.

Speed When you are painting outside, you need to work as fast as you can. The blue boat in the harbour could move off when the tide comes in, or someone could park a vehicle and block your view. Half-hour exercises will help you to increase your speed.

To be able to work fast outside is a bonus.

Discipline At first, you may find that you cannot concentrate on painting for a full half-hour so you will have to keep pushing yourself further in each exercise. The time-limit will also train you to have everything to hand before you start.

Discipline will help you to form good habits. It will also make you go out and paint – not go out and think about it.

For this book, I went out to paint from nature, working in watercolour and in oil. I set myself a time-limit of half an hour for each painting, including drawing, but I did not include the drawing time for a complicated subject. If I found that I needed another few minutes to finish the painting, I used the time, and I have stated the exact time I took for each painting. None of the sketches and paintings has been touched since I finished working on them at the painting scene.

When you have read through this book go out and do some half-hour paintings.

Take an extra five minutes, before you start to paint, to observe your subject. This is very important. If you find half an hour is a little short for you – and it can be – then make it 45 minutes. Don't be tempted to go over an hour or the object will be lost. Add an extra 10 minutes for oil painting because it takes longer to mix the paint and clean the brushes than it does for watercolour.

If you draw slowly, then count only the painting time, but do try to include your drawing time in the half hour. You could start by copying some of my paintings from the book and see how you get on. Try the simpler ones first.

Do note down the time when you start, because you will not remember it. If you are working alone, try not to cheat with the time – it's very tempting, I know. Good luck.

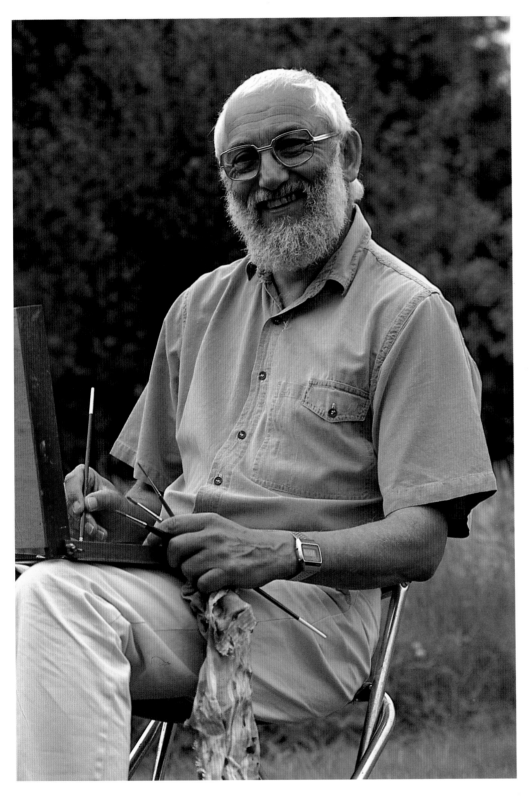

Fig. 1
*Alwyn Crawshaw painting
outdoors*

7

MATERIALS

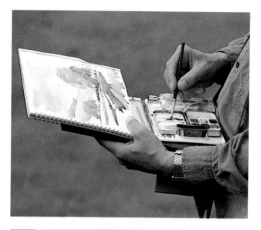

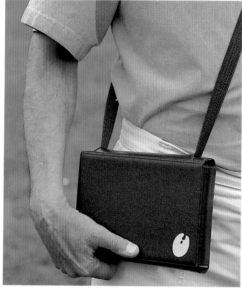

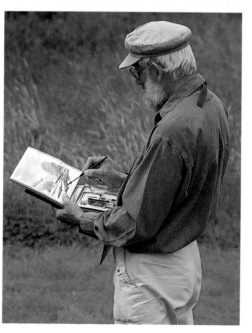

Throughout my painting career I have used Daler-Rowney materials and I find them first class. I use Artists' quality Water Colours but I am happy with their Georgian Oil Colours.

Watercolour
When watercolour painting outdoors, the age-old problems of finding somewhere to put my water jar and having to carry all the equipment to the painting spot prompted me to design the Travelling Studio (fig. 2). It is fitted with six Daler-Rowney Artists' quality Water Colours in a removable aluminium paint box, a No. 5 sable brush, a spiral bound Bockingford Watercolour Paper pad 13×18 cm (5×7 in), and a pencil. It has a rust-proof water bottle and water-cup holder. All this is neatly held together in a tough PVC waterproof case, with carrying strap (fig. 3), and weighs only about 500g (1 lb).

In fig. 4 the kit can be seen in working conditions. The shoulder-strap is round my neck, supporting the kit. The water cup is held firmly on the tray, next to the paint box. My left hand is supporting the pad – the pages are held down by a rubber band at the right-hand side. You can even stand up to paint with this kit.

For the exercises, I decided to work all my watercolours on 29×21 cm ($11\frac{1}{2}$×$8\frac{1}{4}$ in) paper. This is larger than the kit pad, but I just rested the larger pad on the existing one. I used Whatman Watercolour Paper 200 lb Not surface and Bockingford Watercolour Paper 200 lb. I also worked on cartridge drawing paper in a sketchbook. Whatman paper allows you to over-work more, without pulling up previous washes. This is good if the subject is simple and you have time to use it to its advantage. For complicated scenes I used Bockingford 200 lb paper because this gives more character to the paint when applying only one or two washes.

The colours I use are: Crimson Alizarin, Cadmium Yellow Pale, French Ultramarine, Cadmium Red, Yellow Ochre, and Hooker's Green No. 1. I used only two brushes for the exercises: a No. 6 round sable Series 43 and a Dalon Rigger Series D.99 No. 2.

Oil

The problems of oil painting outdoors were sorted out long ago and carrying boxes are manufactured in various convenient sizes. I use a pochade box which takes two 25×30 cm (10×12 in) boards in the lid (fig. 5). I use Low Odour Thinners (an odourless substitute for turps) to thin my paint and I add Alkyd Medium to speed up the drying time.

I used two surfaces for the exercises: primed hardboard and prepared Whatman paper 200 lb Not surface. I painted three coats of Acrylic Primer on the smooth side of the hardboard, and on some boards I mixed a little Acrylic Texture Paste into the last coat to give the surface a slight tooth (grain). I like the surface texture of Whatman paper, and it is lightweight to carry outdoors. Again, I primed the surface with three coats of Acrylic Primer.

I cut a piece of card 25×30 cm (10× 12 in) and then, with a very small piece of double-sided tape, stuck a piece of prepared Whatman paper on each side. This enabled me to carry four working surfaces in the lid of my box, even when they were wet, instead of two boards.

I used six brushes: Bristlewhite Series B.48 Nos. 1, 4 and 6, a Series B.24 No. 2, a Series 43 No. 6 sable, and a Dalon Rigger Series D.99 No. 2. The colours I used are: Crimson Alizarin, Cadmium Yellow, Cobalt Blue, Cadmium Red, Viridian, Yellow Ochre, and Titanium White.

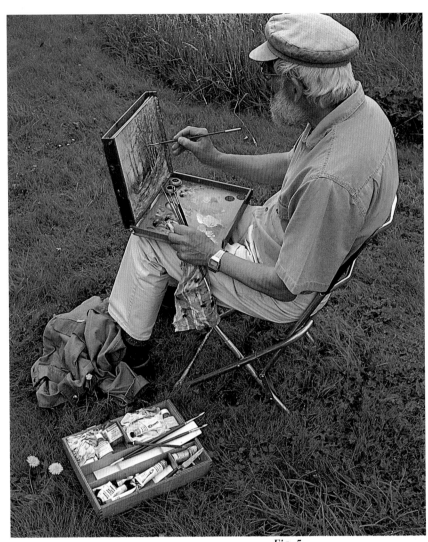

Fig. 5
Alwyn Crawshaw using the oil painting kit, the open box on his lap and the contents on the ground at his side

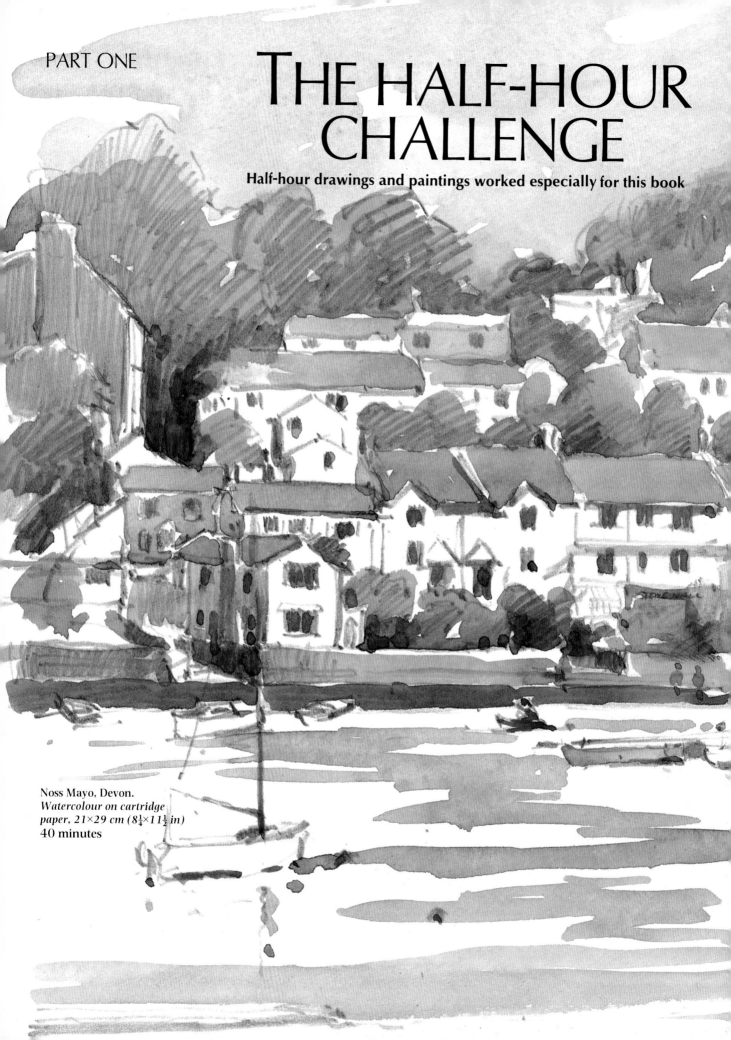

PART ONE

THE HALF-HOUR CHALLENGE

Half-hour drawings and paintings worked especially for this book

Noss Mayo, Devon.
*Watercolour on cartridge
paper, 21×29 cm ($8\frac{1}{4}$×$11\frac{1}{2}$ in)*
40 minutes

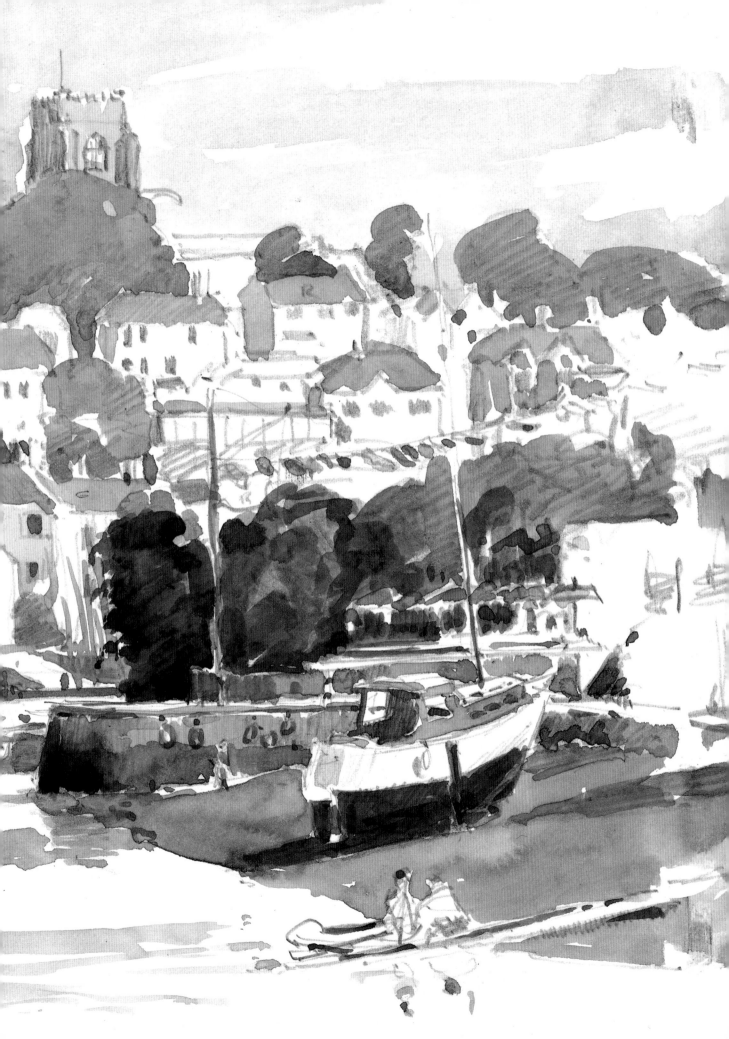

SIMPLE LANDSCAPES

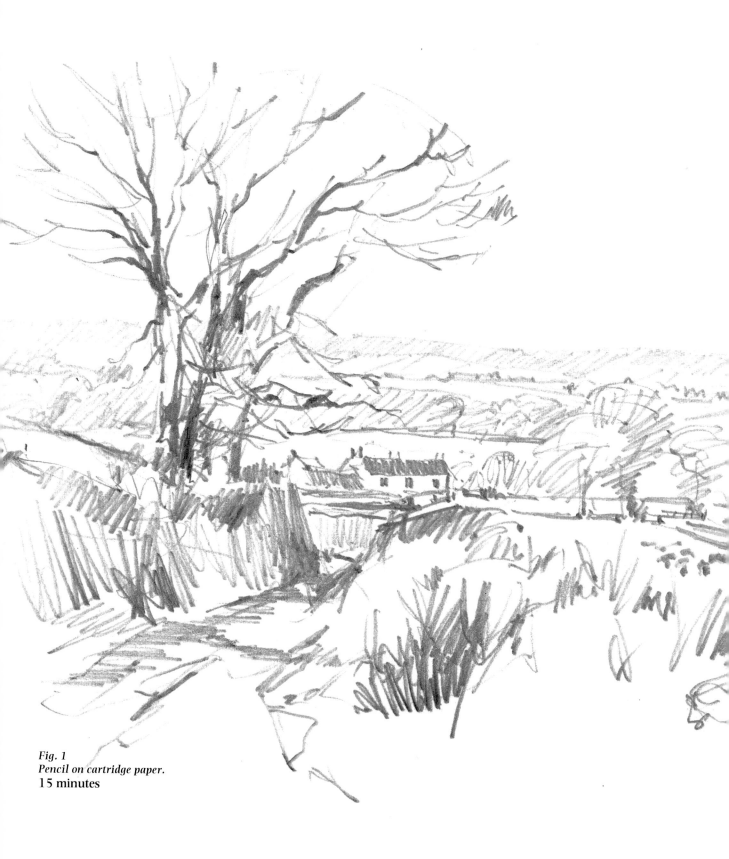

Fig. 1
Pencil on cartridge paper.
15 minutes

Although it was still January, the weather grew warmer and more springlike as the day passed so after lunch my wife June and I went out on our local sketching walk. I took only my sketchbook and a 2B pencil.

It was the bend in the lane and the sun on the farm buildings that made me stop and sketch (fig. 1). The bend is shown clearly by the high hedgerows, typical of Devon, which can give some interesting and creative shapes to a landscape.

I used the 2B pencil, but was annoyed that I didn't have a 3B pencil with me. The atmosphere must have been damp and I couldn't get a dark or crisp line because the cartridge paper itself was slightly damp. Nevertheless, I was pleased with the sketch, and we set off to find somewhere else.

The noise of a tractor coming up the lane behind us seemed as much a part of nature as were the heavy horses which plodded up and down the lanes in the past. We had to get into the hedge to allow the tractor to pass. The lane was waterlogged, and mud and water sprayed over our boots and jeans but I made sure my sketchbook was behind my back, well out of the way of the mud.

Further on I stopped where I was able to rest my pad on a gate to sketch some sheep (fig. 2). By this means I can get a much stronger line than by holding the pad in my hand. Sheep are funny animals. When they hear you, they look at you and appear to be very interested, but then they move away as

Fig. 2
Pencil on cartridge paper.
15 minutes

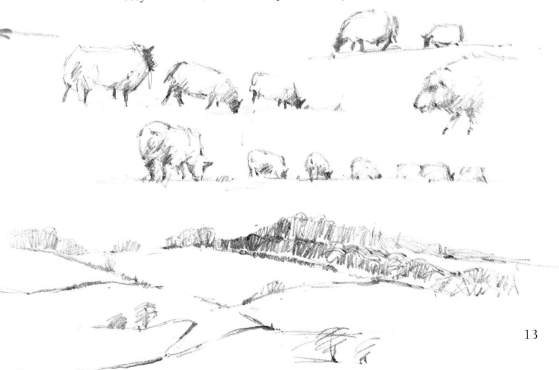

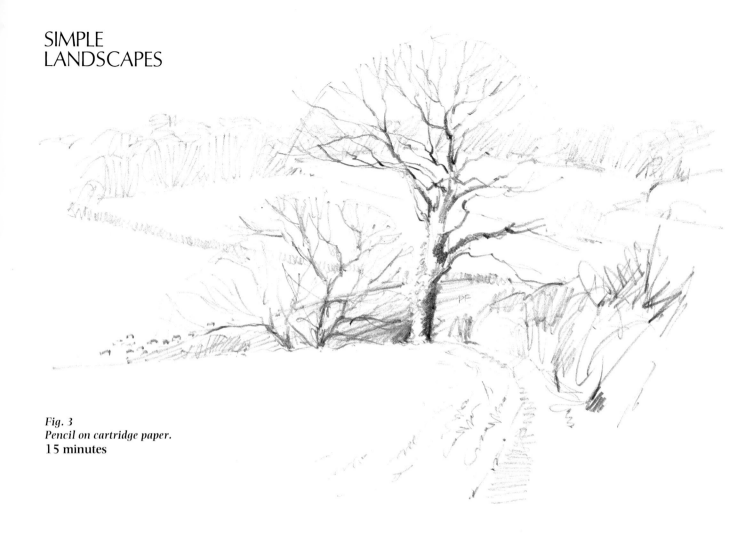

Fig. 3
Pencil on cartridge paper.
15 minutes

Fig. 4
Pencil on cartridge paper.
20 minutes

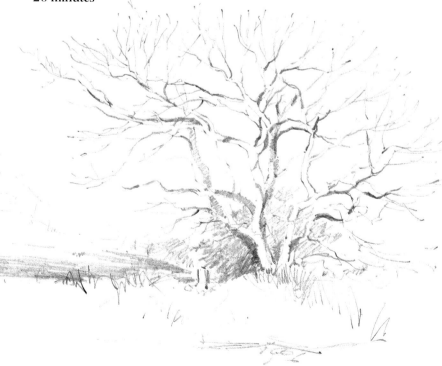

if fastened together with an invisible rope.

The sun was getting low by now and the inspiration for the next sketch (fig. 3) was the warm sunlight on the fields behind the two main trees, which were almost silhouetted against them, except for some very strong sunlight hitting the nearest tree and casting dark shadows on some of its branches. This is the time of day – when you can see strong light and shade – to draw a tree for its own sake and not just as part of a picture.

On our way home, I saw the tree in fig. 4. The low sun was lighting it up with a warm colour, casting strong shadows, and I couldn't go past without putting it on paper.

I began to draw it very carefully, my idea being to make more of an accurate study rather than a sketch, because I could see almost every branch and understand its intricate form. However, my hands became very cold within minutes, so the drawing was speeded up and finished as a very useful working sketch.

14

We had just experienced four days of almost continually overcast skies and torrential rain which had kept me working in the studio. Then the clouds parted, and it was hard to believe that the blue sky – even the sun – was still up there. So it was one of those impromptu sketching trips for June and me.

We had been walking for about 15 minutes, turning round all the time so as not to miss a good sketching scene, when I turned and was stunned by the view (fig. 5). The sun had just broken out from above some oppressive, dark rain clouds, and up the lane the two trees and the hedge were in silhouette. It was breathtaking.

Speed was of the essence, because the effect might be gone before I finished. I fumbled for my 2B pencil and started to draw the trees, then the clouds. I found I needed a softer pencil, to give me more freedom for broader shading and more intensity of tone, so I borrowed June's 4B pencil. After working the sky, I found that the tone of the hedge had to be worked very dark, to make it come forward from the dark clouds. This sketch looks a bit eerie; but then, that is the feeling the scene gave me. I was very pleased with this one.

The clouds were getting lower now and

Fig. 5
Pencil on cartridge paper.
10 minutes

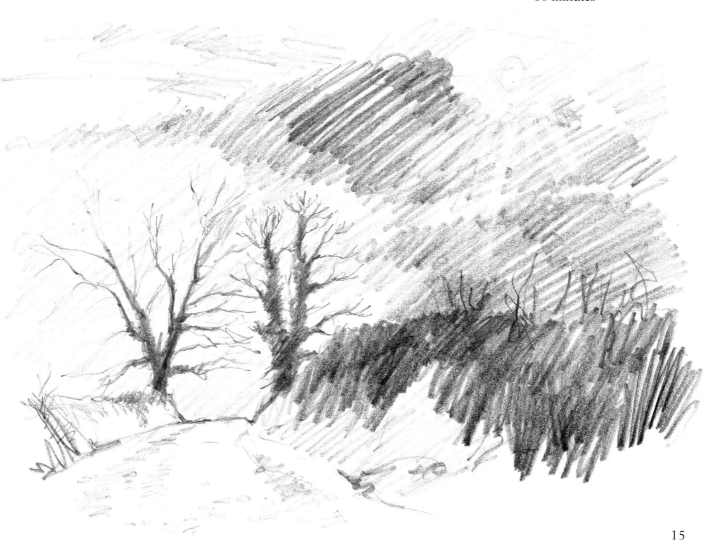

SIMPLE
LANDSCAPES

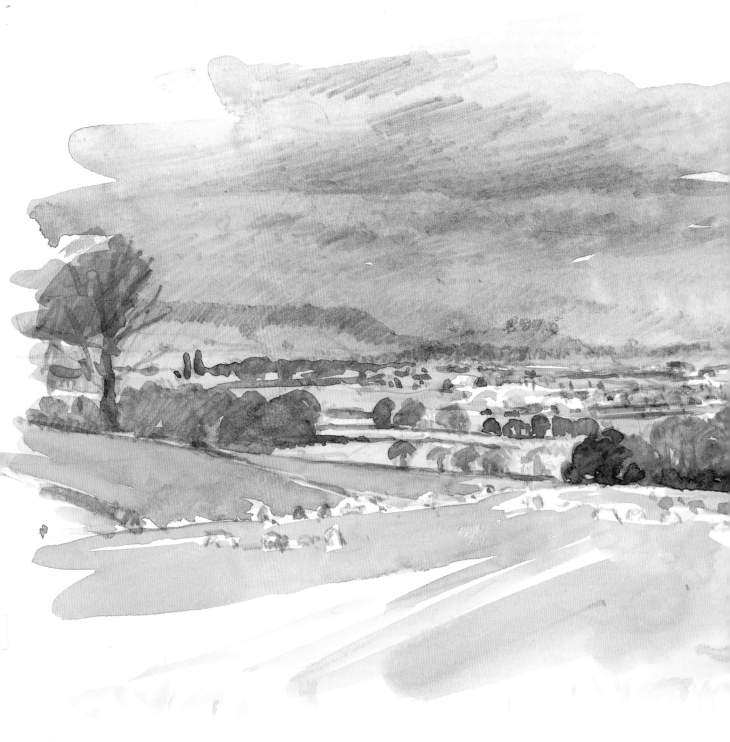

Fig. 6
Watercolour on cartridge
paper.
25 minutes

merging with the hills in the distance. I stopped at a gate at the top of the hill to have a look at the view in fig. 6. As I watched, the sun came out for only a few seconds and lit up some of the fields. The heavy blue-grey clouds hugging the distant hills gave tremendous contrast. I had to sketch it. I didn't have my paints with me so I had to draw it with a 2B pencil and add tone by shading. I painted over the drawing as soon as I returned home and I included this in my time.

When I reached the top of the hill and looked down the lane in fig. 7, I was excited by the whole scene. Because of the dull, watery light everything was blending together. There were no shadows and no strong colours – perfect for a watercolour painting. Why do you always see a watercolour painting when you have only a pencil with you?

I drew the picture with a 2B pencil, standing in the lane and resting the pad on my hand. The middle-distance fields and the path were all left as white paper to avoid shading in the whole of the sketch, which could have become difficult to understand if I wanted to work a painting from the sketch in the future. It also enabled me to complete the picture more quickly and this was important because the light was fading.

Fig. 7
Pencil on cartridge paper.
15 minutes

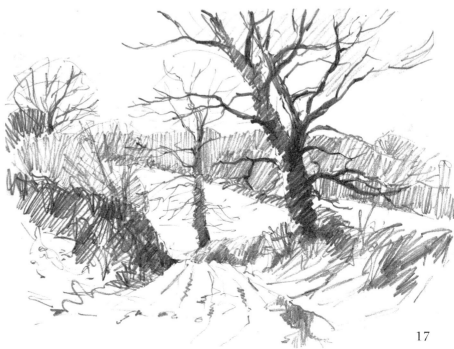

17

FARM BUILDINGS AND ANIMALS

Fig. 8 right
Watercolour on Bockingford
200 lb.
30 minutes

A couple of weeks later, we travelled to South Wales to stay with our daughter Donna and son-in-law Andrew in their farmhouse overlooking the Black Mountain.

There proved to be almost too many good painting spots, but eventually I settled on the view in fig. 8. I simplified the background by running a blueish wash from the top, changing the colour to a dirty green as fields became recognizable in the valley. When this was dry, I put in the greens with just one wash, and didn't touch them again. Then I painted the trees, using my rigger for the small branches. The drawing and painting took 15 minutes each.

Depending on the atmosphere, watercolour can take a long time to dry. One way round this is to paint not quite up to a wet colour, leaving a thin edge of paper showing between the two washes. But the most important factor is to plan your painting so that you can keep working on one area while another is drying.

Moving to Donna's chicken-run, I spent about 20 minutes sketching the hens and ducks (fig. 9). If only they would stand still!

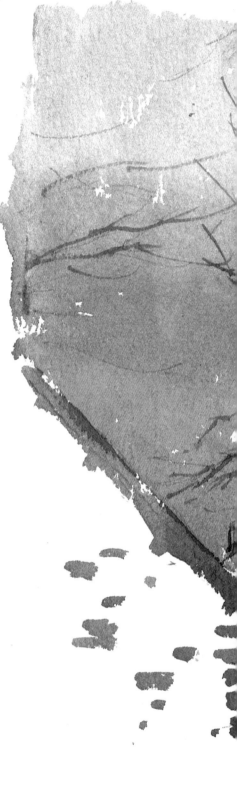

Fig. 9
Pencil on cartridge paper.
20 minutes

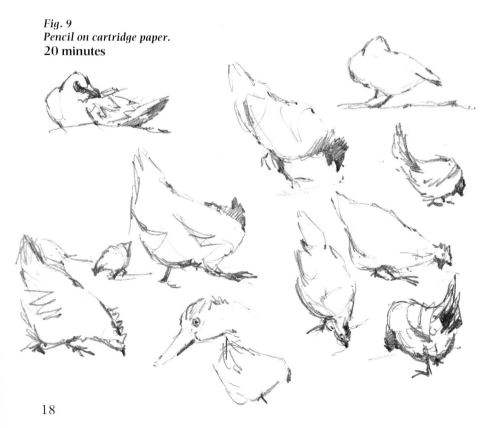

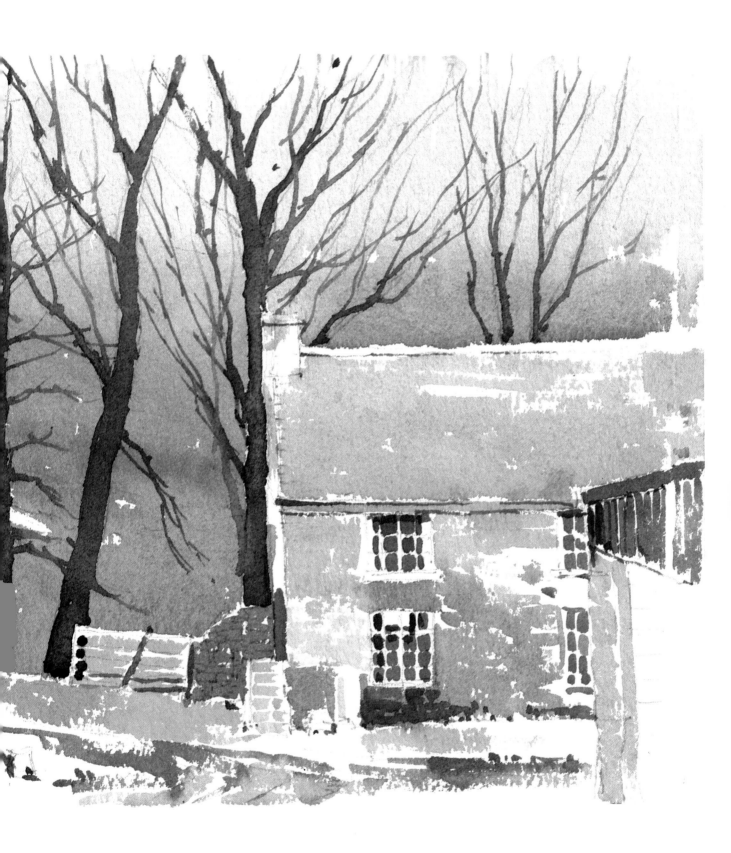

FARM BUILDINGS
AND ANIMALS

Fig. 10
Watercolour on Bockingford
200 lb.
35 minutes

The next morning was warm and misty, and all the colours were soft and inviting. I started to draw the old cottage from a different viewpoint (fig. 10). Then I painted the sky and I found that the paint was drying more quickly than on the previous afternoon. To me, the important part of this painting was the open doorway to the left of

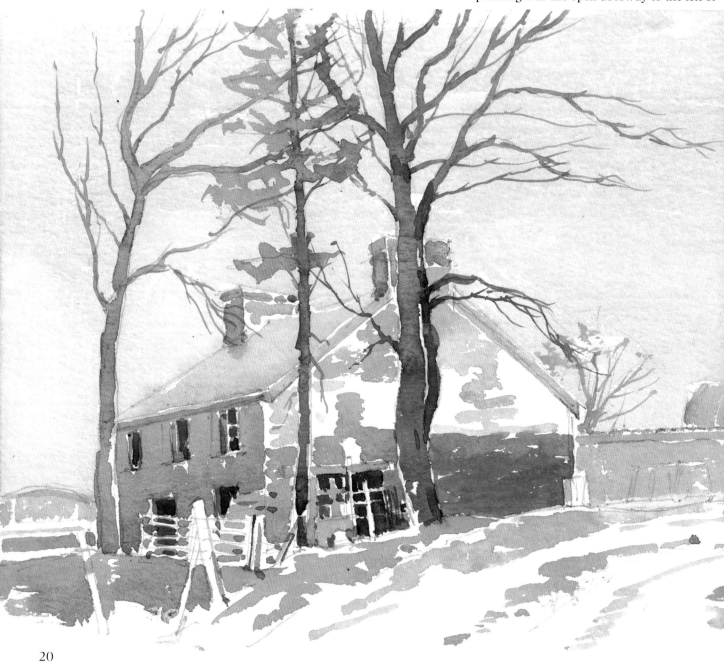

Fig. 11
Watercolour on Bockingford
200 lb.
30 minutes

the centre tree. It was intensely dark and, with the white post in front, gave the darkest and lightest accents in the picture.

The trees were painted after the cottage, with one wash. When this was dry, I added some darker accents on the main tree and in particular the right-hand branches, which I put in shadow. I took 15 minutes drawing and just over 20 minutes painting. This extra time was taken up by tractor-dodging; the same one passed me six times!

Donna's farmhouse is the scene of my next painting (fig. 11). On the left of the house I let the wet wash of the mountain hit the wet sky in two places. This helped to soften the distance. Although the roof was grey, notice how much green moss was growing on the tiles. The telegraph pole on the left was actually just out of my picture, but I put it in to help the composition. Because of the lack of sunlight, I had to emphasize the differences in tone between the front and side of the house. Drawing took 10 minutes and painting 20 minutes.

In a painting this size white is important: if you cover all the paper, your painting can

FARM BUILDINGS AND ANIMALS

Fig. 12
Watercolour on Bockingford
200 lb.
25 minutes

look dead. Let white areas happen; you can always paint them in at a later stage if you feel the painting would benefit, but remember that you can never reclaim a white area once it has a wash on it.

After lunch we walked over the hill and as the clouds parted, the sun struck some of the landscape (fig. 12). That decided me to paint it. The sun didn't come out again so I had to memorize where it lit the fields. I started at the top of the picture and worked down, wet in wet, changing the colours as I went. When this was dry I painted over it a delicate wash on the distant mountains, and then with stronger colour worked in the middle distance trees. Finally, I put in the tree on the right.

In the next painting, the stones in the foreground are very important (fig. 13). If you ever see anything in the foreground that makes an interesting addition to a flat area, use it, even if you exaggerate it.

The distant valleys and mountain were simplified to avoid overpowering the farm buildings. When I paint close-up trees I suggest separate branches, but here the distant winter trees have merged to become a tonal shape.

I had just started to paint in the trees behind the buildings, when I heard that old familiar noise: at the bottom of the field a tractor had started to fertilize the field. As it came past I was showered with small lumps of fertilizer (non-smelly)!

Back at the farm, I sketched Andy at work on a chicken-house (fig. 14). I drew this on cartridge paper with a 2B pencil, then painted over with watercolour. I drew the hut first, then put Andy in when I liked the position.

In a sketch like this you must decide which elements you want to show, then omit or carefully suggest the rest of the scene. I left out the background completely, except for a suggestion of a hedge on the right. The foreground has been over-simplified and so the important elements can be seen and understood easily.

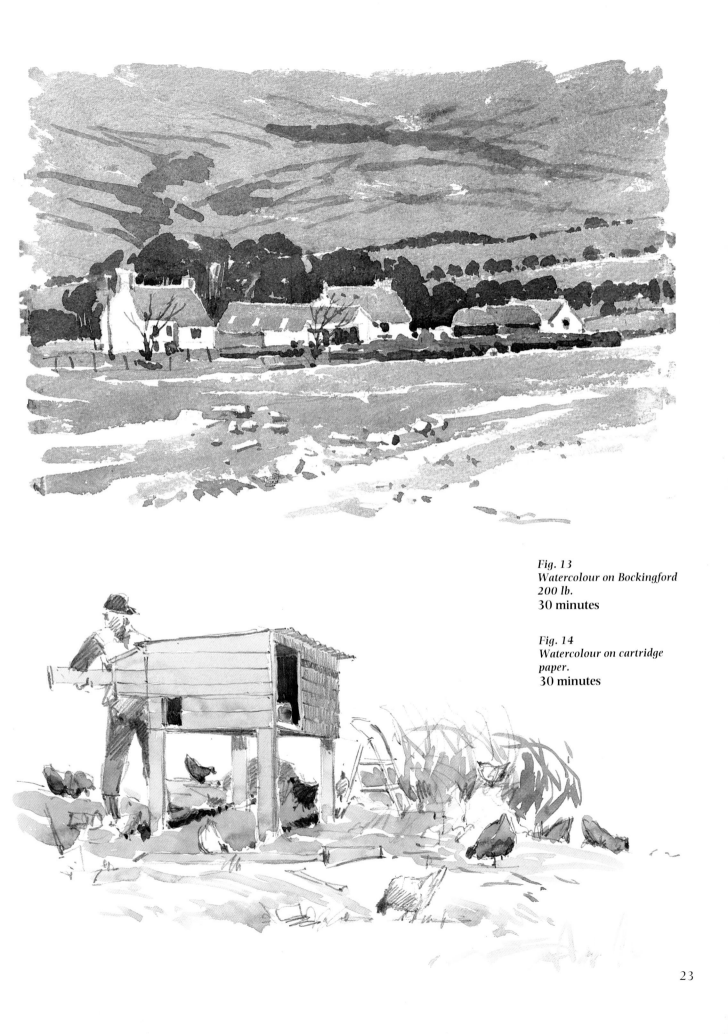

Fig. 13
Watercolour on Bockingford
200 lb.
30 minutes

Fig. 14
Watercolour on cartridge
paper.
30 minutes

23

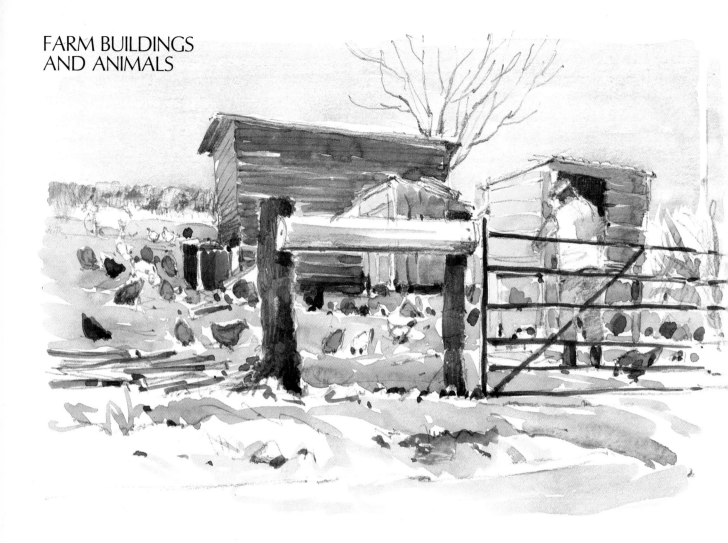

Fig. 15
Watercolour on cartridge
paper.
30 minutes

In the kitchen, warming my hands, I was inspired by what I saw from the window (fig. 15), so I decided to try this on cartridge paper in my sketchbook. I wanted to give the impression of activity, and to show the warm browns of the huts, ground and chickens.

I drew the highest hut first, then established the ranch-style fence in the foreground, the gate and then the other two huts. I drew Andy when he leaned to the left, thus exposing the dark interior of the door opening, and showing him light against dark. I also shaded some areas with the pencil before painting.

First, I painted the sky, the huts, and the ground. I painted very freely around the chickens, and when this was dry I used Cadmium Yellow Pale with Crimson Alizarin to suggest them, leaving some white. I then added some suggestion of chickens over the ground colour. Andy was painted next, and finally the quick suggestion of the foreground and gate. This painting took half an hour and I was very pleased with it.

A disadvantage with oil is the preparation time, and the cleaning up afterwards. The next morning I had planned to do two oil paintings but when I had finally got everything ready, I saw a snow squall coming down the valley. Determined to paint at least one picture in oil, I sat in the boot of my estate car so that, if there was another shower, I could cover my painting and equipment quickly.

I worked on primed hardboard, drawing with a No. 6 sable brush and using Cobalt Blue mixed with turps.

Planning is just as important with oil as it is with watercolour. I worked from the top downwards, painting in between the trees (fig. 16). Had I covered the trees, when I painted them I should have been working over wet paint, making it difficult to get a dark tone.

I left white board for the white farm buildings – the lightest tones – and then painted in the trunks of the trees – the darkest tones. Next, I worked the shadows and then the path. At this stage the painting was almost done. I put in the smaller branches of the trees, cleaned up the farm area a little, added the highlights on the trees, and finally painted some light on the field to the left of the farm.

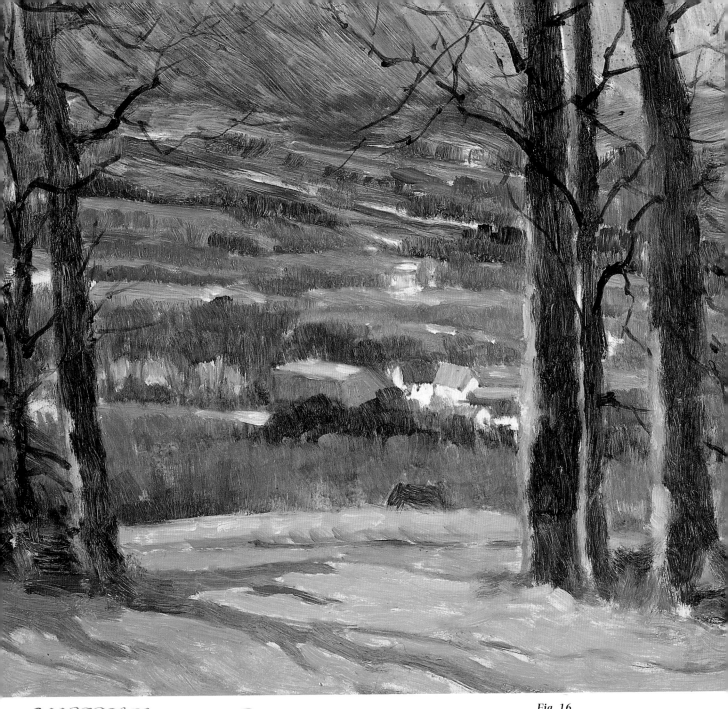

Fig. 16
Oil on hardboard.
40 minutes

25

CHANGING LIGHT

River estuaries, with their rugged, unspoiled and untidy appearance, have always fascinated me, so we decided to spend a day at Burnham-on-Sea, where the River Brue flows into the Bristol Channel.

I was inspired by the view in fig. 17: the mud and water, the high horizon, and the warmth of the buildings in the distance. I sat down, deciding that this was going to be a masterpiece.

It took seven minutes to draw. Then I painted the sky and continued down into the river with the same colour. This was a mistake. Afterwards, I found that I wanted the river a much lighter tone than the sky colour. Usually, I paint the water nearer the end for that reason, but I let excitement take over and didn't plan the picture well enough. It looks fine but I know there should have been more sparkle on the water and mud banks.

Further up-river I painted the view in

fig. 18. I was very excited, but cautious. I painted the sky, which was growing darker and more threatening over the boat-yard, then the buildings, grass and mud banks. Finally, I painted the water, using only a few brush strokes to suggest movement.

Note the contrast between the dark sky over the boathouse and the white paper that I left on the river banks and water. This helps to balance the picture and to accentuate the brightness of the sunlit mud and water.

I had an overwhelming desire to paint the mud banks in oil, and I decided to return – when I hoped the tide would be out.

Moving closer to the boat-yard, I did a quick pencil sketch (fig. 19). It is a little fuzzy because my hands were very cold by then, but I do like the distinctive shape of the yacht on the right.

Three days later we were back and sadly

Fig. 17
Watercolour on Whatman
200 lb Not.
33 minutes

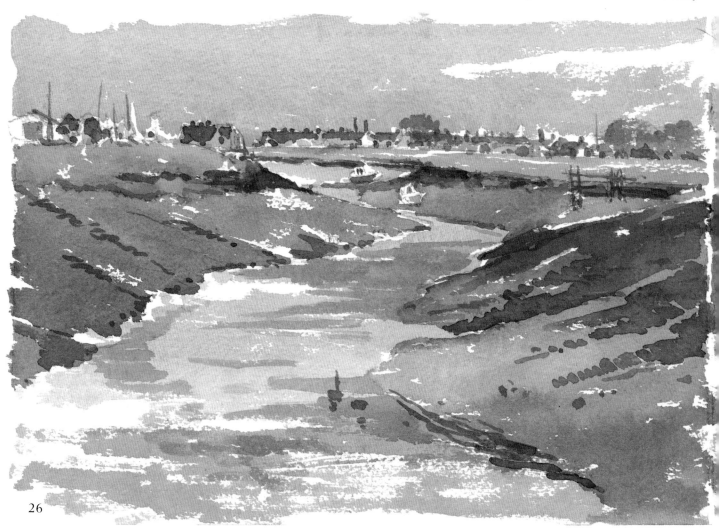

26

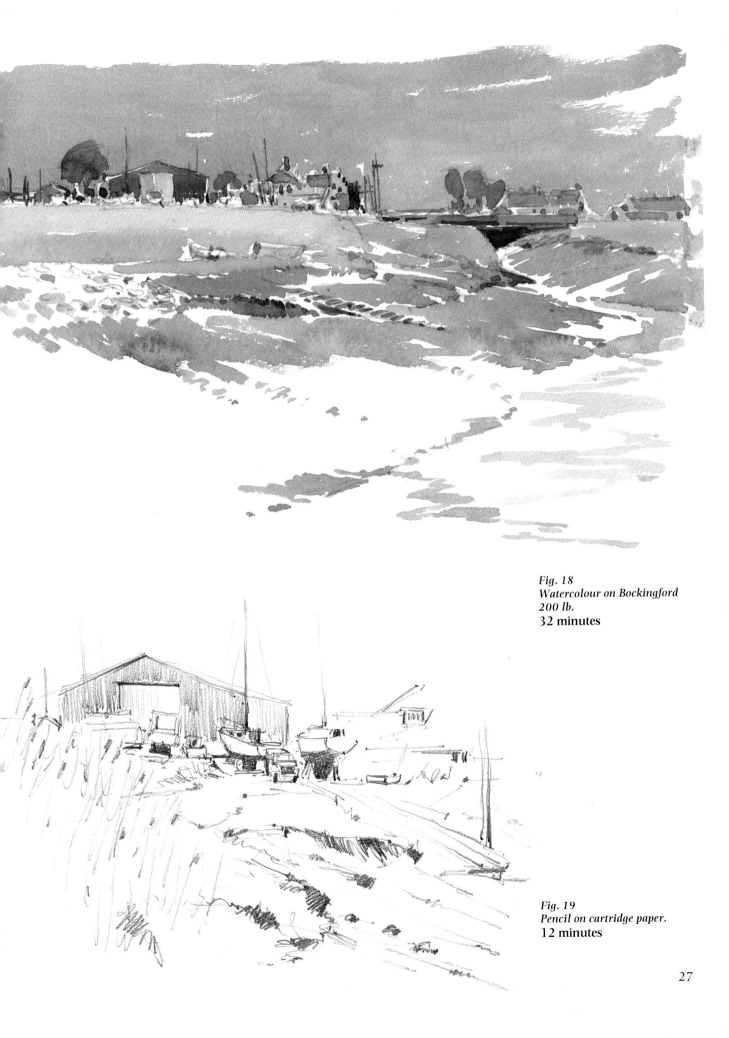

Fig. 18
Watercolour on Bockingford
200 lb.
32 minutes

Fig. 19
Pencil on cartridge paper.
12 minutes

CHANGING LIGHT

looking at the estuary in all its rain and windswept dreariness. So we drove inland to paint a rain-swept landscape from the car. I looked through the windscreen at the scene in fig. 20, to find that the clouds had lifted and some blue sky was showing. I sat in the back seat with my pochade box on my knees and drew with a turpsy mix of French Ultramarine and Crimson Alizarin. I used the same mix to paint the blue sky areas and added Yellow Ochre for the darker sky to the left.

As I was doing this, the late afternoon sun lit the clouds behind the right-hand trees with a strong pink light and I left this area unpainted, knowing that I would put in the pink colour near the end. I then worked the silhouette background and the right-hand tree, the grass and the road.

It took me 35 minutes to reach this stage and I could have spent another 10 minutes working on the grass and road.

I turned the car round and the view was breathtaking: the dark sky, the darker distant hills, the dark coastal trees and all the fields, lit up in places by the low winter sun (fig. 21). Notice the dull pink light in the sky just above the hills on the left. This helps to give depth to the sky. The foreground fields and path were left, as I had underpainted them, except for one or two brush strokes added to give a little definition. I felt that no more work was necessary but, on reflection, I believe I could have made the foreground trees a little darker to separate them from the distant hills.

Meanwhile, June was sitting in the front seat, painting the scene in watercolour (fig. 22). It is interesting to compare our two approaches and the contrast between an oil and a watercolour painting.

Back again at the estuary, the sun was almost gone over the Bristol Channel, but

Fig. 20
Oil on hardboard.
35 minutes

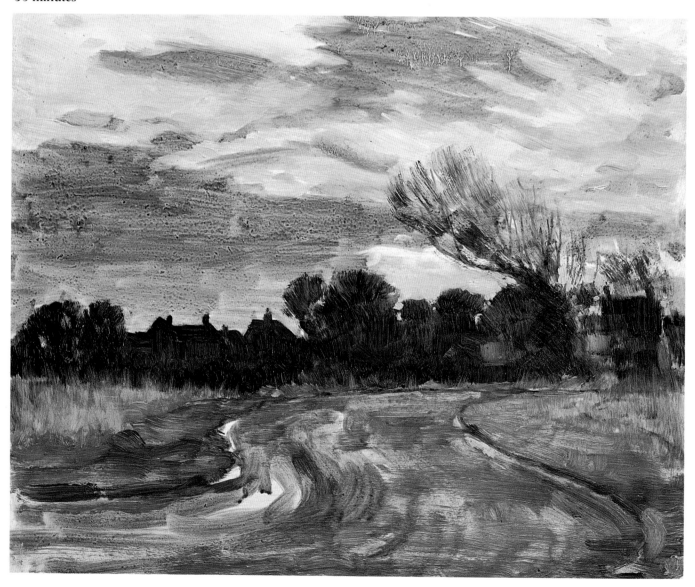

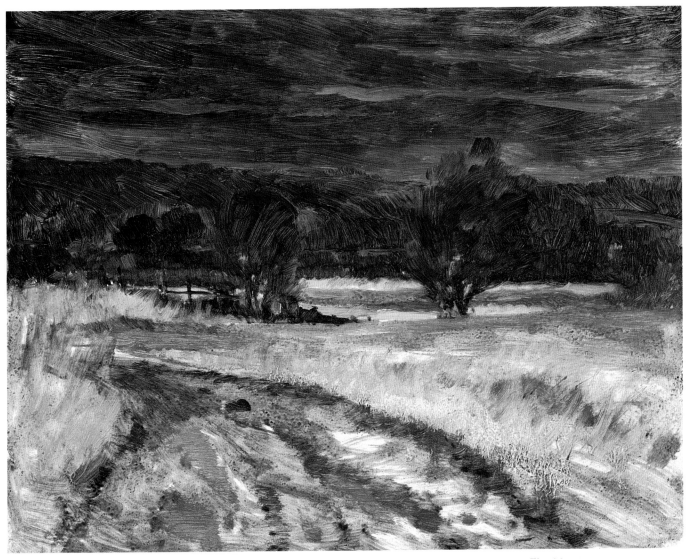

Fig. 21
Oil on hardboard.
40 minutes

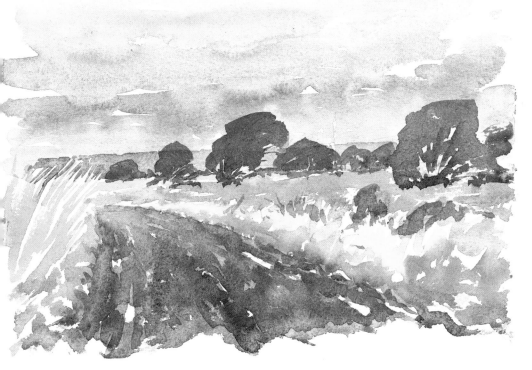

Fig. 22
Watercolour on Bockingford
200 lb.
30 minutes

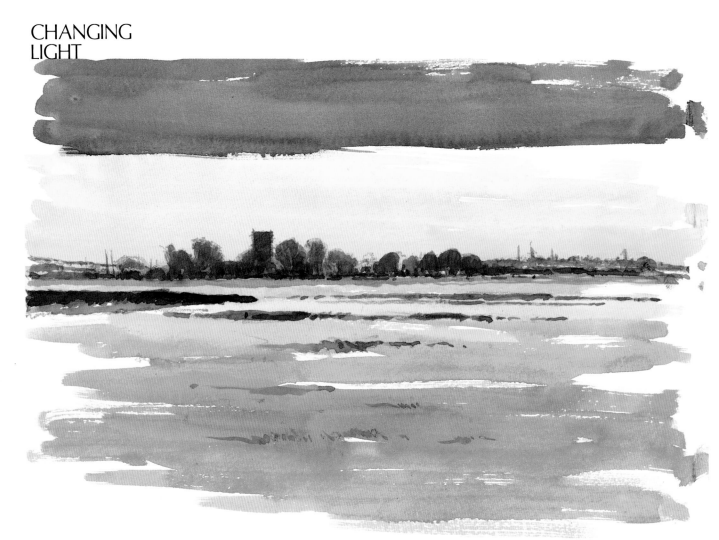

Fig. 23
Watercolour on cartridge paper.
30 minutes

Fig. 24 opposite above
Oil on hardboard.
32 minutes

Fig. 25 opposite below
Oil on hardboard.
47 minutes

its fading, golden-pink light flooded the scene in front of me. I decided to sketch this scene with a 2B pencil on cartridge paper (fig. 23). After this I laid in some simple watercolour washes. The dark cloud above is important because it gives brightness to the sky behind the church and trees. The colour of the marsh grass and reeds was lightened by the pink glow of the sun.

Early the following morning, we went down to the estuary to paint the mud banks in oil. But it was high tide. No mud banks!

There was only one thing to do – to paint what was there. The sun was yellow-gold behind the broken, warm-grey clouds, and I started to look with new interest at the scene (fig. 24). I used prepared hardboard but this time I put a turps wash of Yellow Ochre and Crimson Alizarin over the white primer. I painted the clouds with horizontal, broken brush strokes, leaving the priming colour for the sunlit clouds. I added pink, and painted over the priming colour as I approached the horizon. I drew with my usual turps and Cobalt Blue mix, and filled in most of the middle distance in silhouette with the Cobalt Blue. The river was suggested by dry-brush technique over

the priming colour. I was very pleased with this painting. I felt I had captured the early morning atmosphere.

The tide had turned and was going out very fast, revealing glorious wet mud. Up-river we found an old broken landing-stage with a severe list to the left, silhouetted against the sunlit mud (fig. 25) – and here I was at last, paints at the ready, with mud all around me.

Well, it wasn't as easy as it looked. Because the sun was not out constantly, the mud changed in character every few minutes. First, it would be very luminous and bright, with the water much darker; then the water would miraculously become bright and sparkling, with the mud mauve and brown. I had no trouble with the middle distance, but when I was ready to work on the mud, the light changed again and the mud and water this time looked almost the same tone. I painted what I saw then, although I feel it is a little too subtle.

I have to admit I was worried, and fussed around the mud and water. I knew I was out of my half-hour time-limit for this one.

In the afternoon, as the sun was going behind a massive bank of clouds, I began to

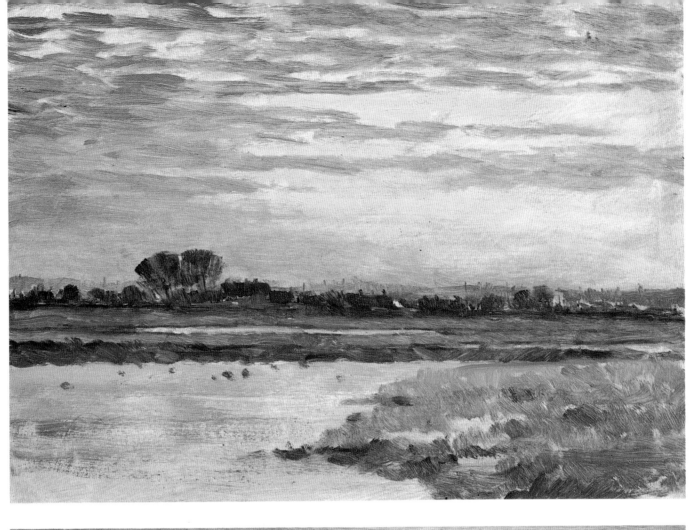

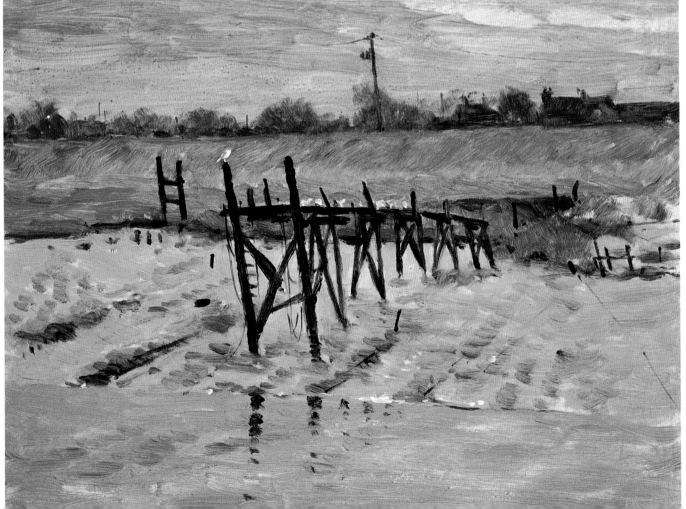

CHANGING LIGHT

Fig. 26
Oil on Whatman 200 lb Not.
35 minutes

paint the view in fig. 26, working on primed Whatman 200 lb Not paper. The paint tends to drag and leave the grain of the paper showing, which can be an advantage for some effects.

I like this painting; it is unlaboured and very soft looking, no doubt due in some measure to the paper on which I worked, which has a more absorbent surface than hardboard. I was reasonably happy with the mud, but I know I can make more of a feature of it if I can find time to sit, observe and paint it.

June painted a watercolour of the same scene (fig. 27) on Bockingford 200 lb paper. She saw it as a very wide view, while I concentrated on just the farm

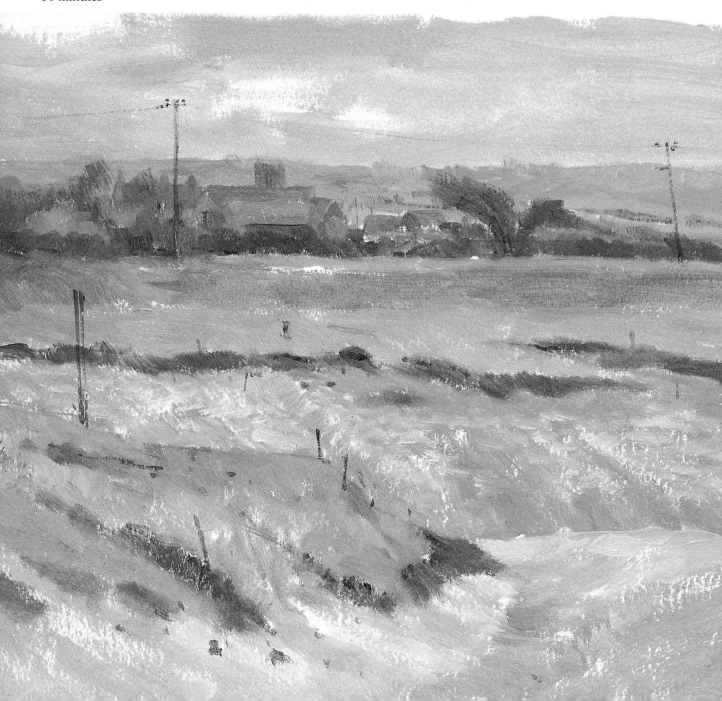

buildings, bringing everything closer. I like the way that she expressed the light on the mud bank.

After a shower of rain, I did a few sketches around the boat-yard. Fig. 28 is the one I just had to do. While I worked on these paintings I must have protected my painting equipment from and spoken to more dogs than human beings. Looking back from the boat-yard at one point I saw in the distance three people with their dogs. It's a fun sketch; it will always have meaning for June and me.

By the river again, next day, the low, windswept clouds were alight with golden sunlight, made even brighter by the dark rain clouds hovering menacingly above.

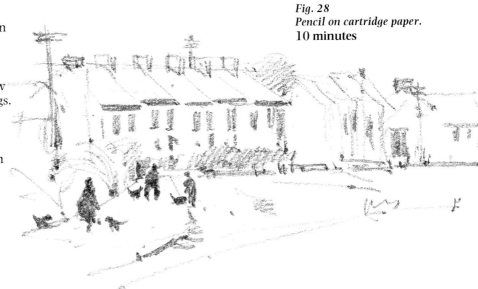

Fig. 28
Pencil on cartridge paper.
10 minutes

Fig. 27
Watercolour on Bockingford
200 lb.
35 minutes

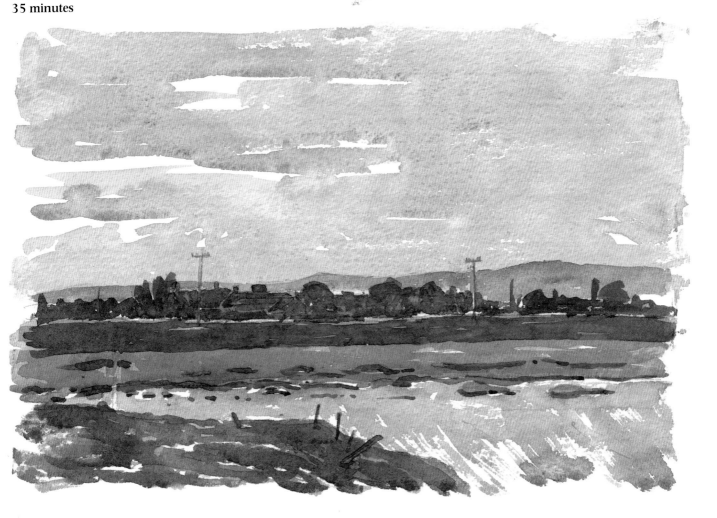

CHANGING LIGHT

The light changed constantly on the distant hills (fig. 29).

I used primed Whatman 200 lb Not again. This time I worked the sky with mixed paint, but without white, using turps as my medium. I worked it like a watercolour, leaving white paper for the light-coloured clouds and the river. From then on I painted as I normally do when using oil paint.

The advantage of working with a paint and turps wash is that you can cover the paper quickly and freely, and this establishes the shapes and tones of the whole picture. It works well on watercolour paper (properly primed). The grain and semi-absorbent surface helps to control the fluid paint. This technique can also be used

Fig. 29
Oil on Whatman 200 lb Not.
32 minutes

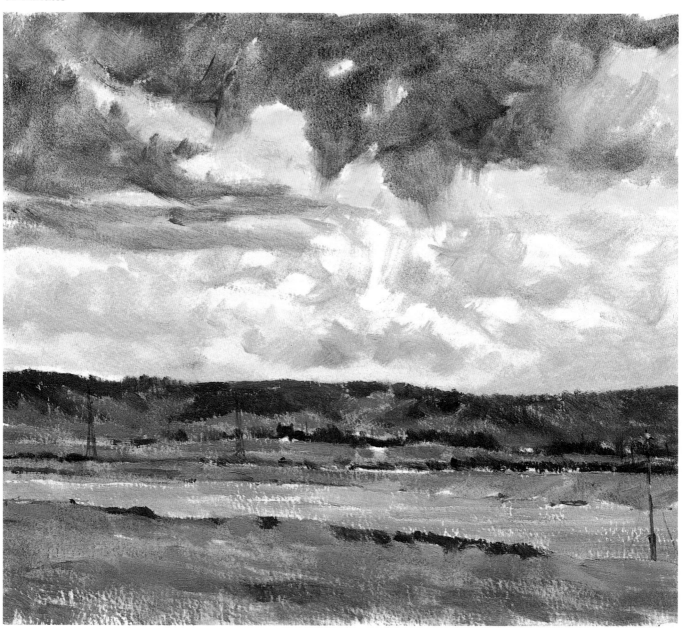

to good effect on canvas.

Oil painting on paper does have one disadvantage, however: it is harder to spread the paint over a large area. I overcome this in three different ways. First, I add much more Alkyd Medium to the paint, which gives it body but also makes it more runny. Second, I add turps to the mix, which again makes it more runny but thinner. Last, I mix more paint than usual.

Back to the painting. I really enjoyed painting the sky. After putting on the turps wash, I let the brush dance around with controlled abandon, forming the sunlit clouds. I then worked in the rest of the painting.

Further along the coast, with the heavy skies behind me, I looked across the Bristol Channel to Wales in the distance, and the islands and lighthouse all bathed in March sunlight (fig. 30).

I painted the sky in exactly the same way as fig. 29, but this time it was more serene. The colour of the water intrigued me. In the distance it was a light cool grey, but the water from the islands down to the light blue colour running across the picture was a muddy brown. I thought the latter was mud, and that the bright blue colour running underneath, across the picture, was water. I was mistaken – it was the reverse.

There are quite a few points I like about this painting: the yellow-pink clouds; the simplicity of the distant hills; and my favourite part is the island on the left.

In fig. 31 the sun had just caught a

Fig. 30
Oil on Whatman 200 lb Not.
35 minutes

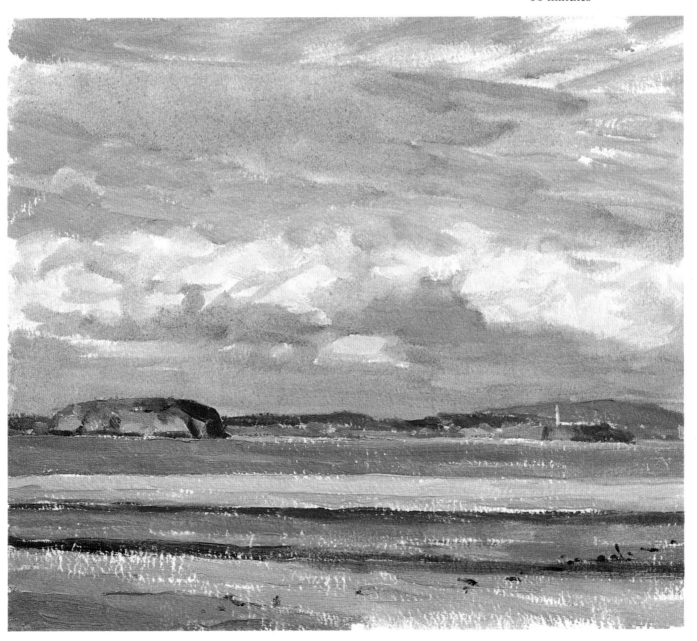

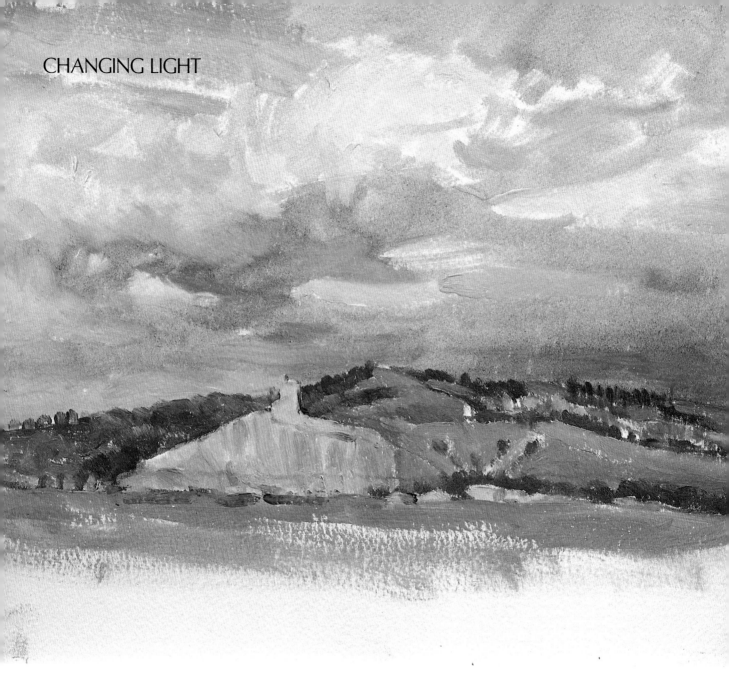

Fig. 31
Oil on Whatman 200 lb Not.
26 minutes

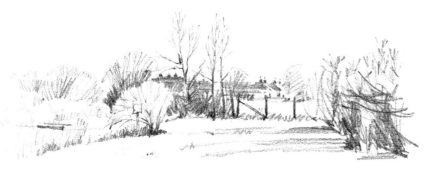

building on the top of the cliffs and it reminded me of a classical type of painting. As well as this, it was the sky that inspired me to paint this scene.

I worked on primed Whatman paper, as before. After the sky, I painted the background hills and then the building. I had just finished this when the rains came.

I quickly put some green to represent the field underneath the cliffs, but couldn't continue as the whole of the painting was now covered with raindrops. So it is unfinished, but I had only four minutes left anyway. I do like the sky in this painting; I feel the dark clouds are receding quite well into the distance behind the hills, and there is a considerable depth of subtle tonal range in the sky. This helps to keep a painting moving and to create the illusion of light.

The following morning, we worked from the beach at Weston-super-Mare (fig. 32). I wasn't very pleased with my oil painting; I felt it was a little lifeless and the beach too orange, and far too strong. I wasn't sufficiently inspired, and it isn't one of my best half-hour paintings, I think.

But June had settled down and did a very pleasant, fresh watercolour of the same scene (fig. 33).

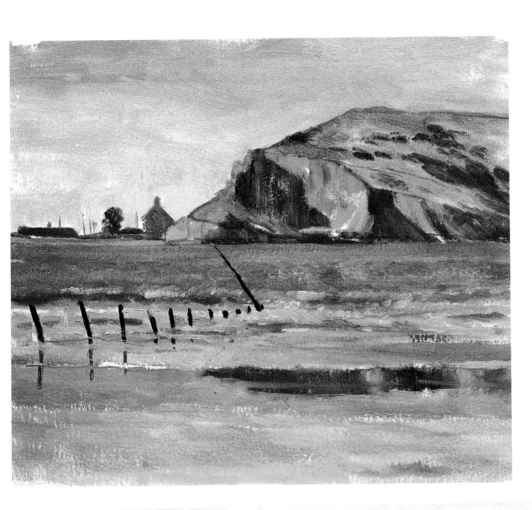

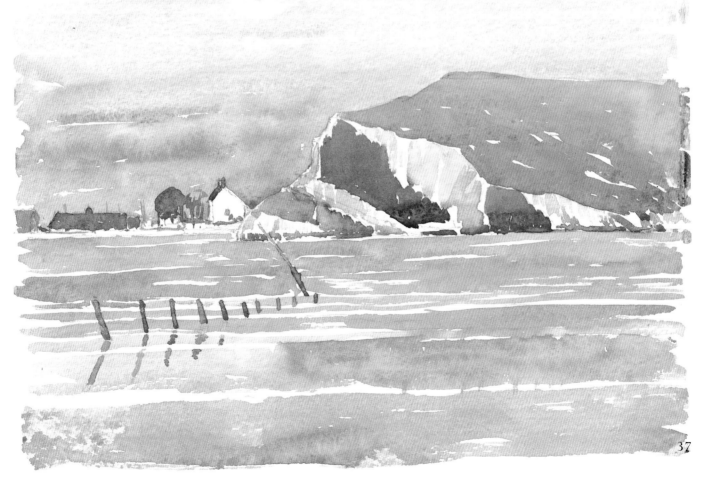

CITY BUILDINGS

A working visit to London gave me an opportunity to do some paintings of the capital. As we walked along the Embankment, I looked across the Thames towards Big Ben and the Houses of Parliament (fig. 34). It was the busyness of the scene that inspired me. Heavy clouds had built up behind Big Ben, but then the sun came out and lit the buildings with soft golden light.

I wanted Big Ben to be the centre of interest so I drew this first, starting at the top, using a 2B pencil.

I had forgotten to check my watch, so I asked June to check my starting time – just as I was drawing the clock face on Big Ben! Because I had to capture the scene in half an hour, my observation had to be at its keenest. Perhaps that was why, when I started, I saw the face on Big Ben as only a shape to be drawn, not a clock.

Next I drew the bridge. I took a little time to see that this and Big Ben were reasonably correct, and this gave me fixed positions from which to work the rest of the drawing.

There is one very important point to be made here. All the windows, gargoyles, parapets and highly complex masonry of these buildings cannot be drawn in a free-style watercolour painting, especially one to be finished in half an hour. You must try to get the important large shapes relative to each other in size and tone, and let the broad detail be suggested by your brush – or even leave it out, as I did on the extreme left of the picture.

If you are a beginner, I suggest you do not practise drawing on a subject like this. Start on still-life objects around your home and then go out into your garden to work at the buildings you can see there. When you have gained confidence, venture further afield, until you are able to stand in front of something like Big Ben and be excited, not terrified, at the prospect of drawing it.

To work a watercolour painting like this – free and unlaboured – you must have your centre of interest more carefully worked so that it stands out clearly. If you look at my painting you will see that Big Ben and a boat below it are drawn and painted carefully, but also freely, and the eye accepts the rest of the picture.

I was very happy with this painting, especially as I barely exceeded the time-limit, and I was standing.

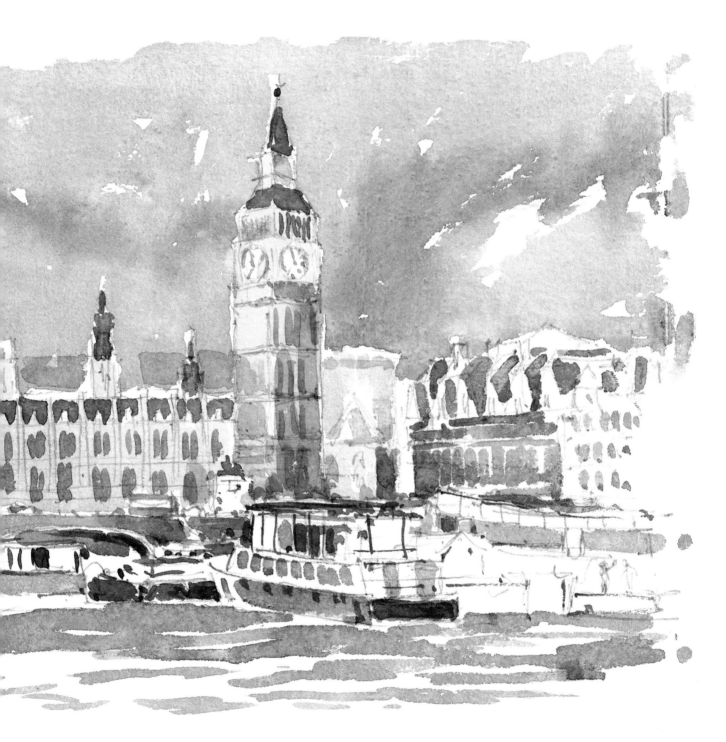

Fig. 34
Watercolour on Bockingford
200 lb.
33 minutes

CITY BUILDINGS

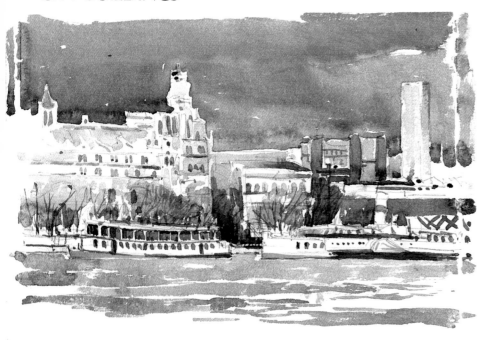

Fig. 35
*Watercolour on Bockingford
200 lb.*
30 minutes

Further along the Embankment, I looked in the opposite direction, towards Charing Cross Bridge (fig. 35). The sky was very dark behind the buildings and when the sun came out everything seemed white in contrast to the sky and river. I sat on a public bench to do this one. I approached it in the same way as fig. 34, making sure that the boats were drawn reasonably well. But, for me, the composition is not as good as the first; it is too flat, too horizontal.

In St James's Park I sat down to paint the view looking towards Horseguards (fig. 37). I used the wrought-iron gateway as the focal point and worked away from it. I drew the people as they appeared – when I liked their positions.

Looking at the painting later that evening, I wondered whether the path would have been better darker, giving the buildings even more sunlit brightness. I am still not sure.

Fig. 36
Westminster and the Houses of Parliament from the South Bank. *Watercolour on cartridge paper.*
25 minutes

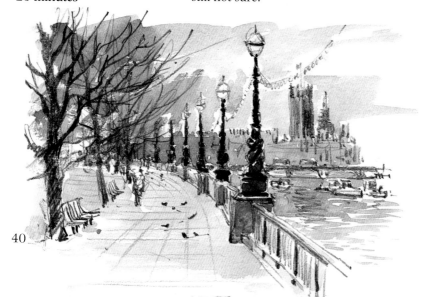

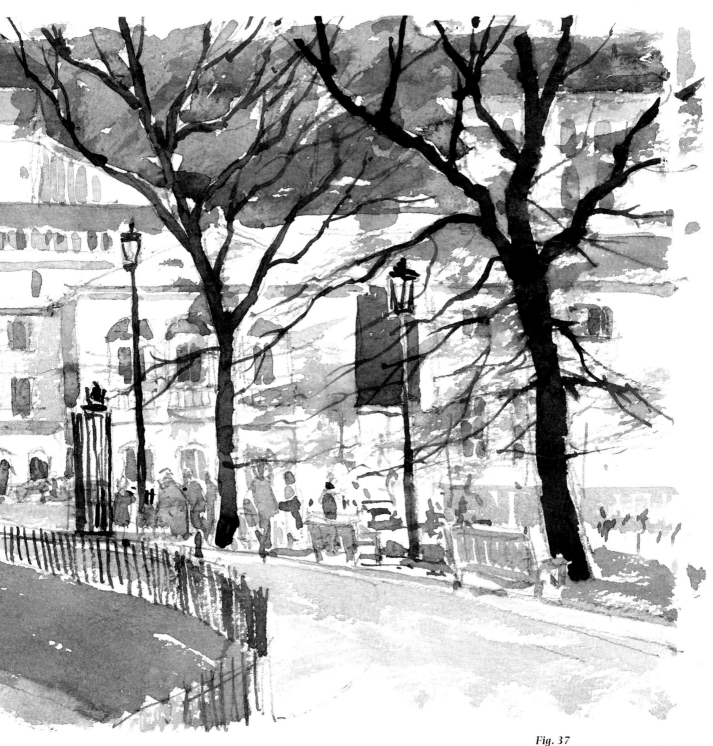

Fig. 37
Watercolour on Bockingford
200 lb.
34 minutes

41

HOLIDAY PAINTING

The secret of painting on holiday without allowing your painting to become the dominant feature, is to take advantage of opportunities that arise naturally. And a half-hour challenge is ideal.

One of the most difficult ways to sketch, but one of the most effective ways to learn observation, is from a moving vehicle. It is best to choose a subject with an obvious shape and one that is a long way off because it will be in view for longer than something close up.

Make only small sketches: the two in fig. 38, which I sketched from the coach while on holiday in Italy, are on one page of my sketchbook. In each case the pencil work took less than a minute and the simple colour washes were done from memory minutes after we had passed by.

The scene in fig. 39 is St Mark's Square, Venice, where we stopped to do some sightseeing. The pigeons that covered the ground are an important feature of my sketch.

I used a 2B pencil and shaded in some of the tones. A hazy mist made the colours very subtle. For the sky I used a mix of French Ultramarine, Crimson Alizarin and just a touch of Yellow Ochre towards the horizon. The distant buildings were mixed from the same colours. I suggested the people very freely with simple strokes of my No. 6 sable brush.

An hour later, while sitting outdoors at a café table, I painted the same scene from a different viewpoint (fig. 40). This painting is much warmer than the one in fig. 39 because the haze had cleared and the sunlight was much stronger.

Rome was our next stop. St Peter's Square is enormous and when we arrived it was full of people. At the foot of the long

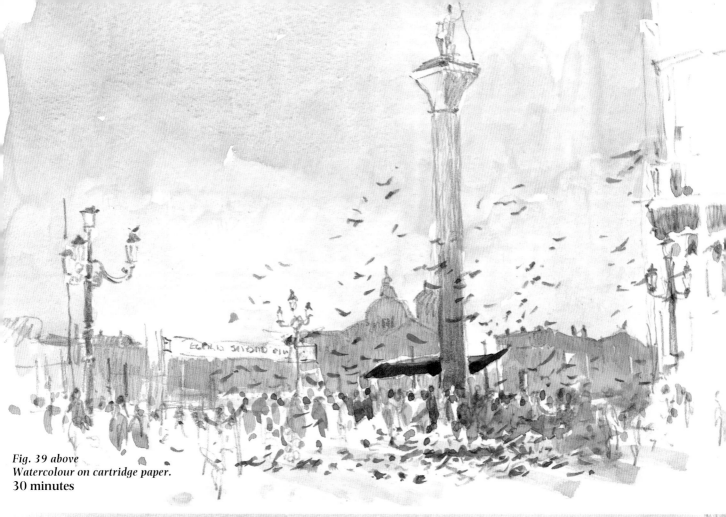

Fig. 39 above
Watercolour on cartridge paper.
30 minutes

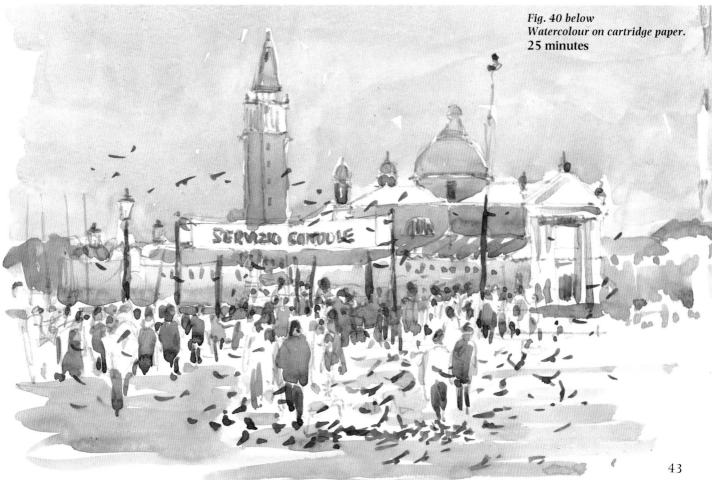

Fig. 40 below
Watercolour on cartridge paper.
25 minutes

HOLIDAY PAINTING

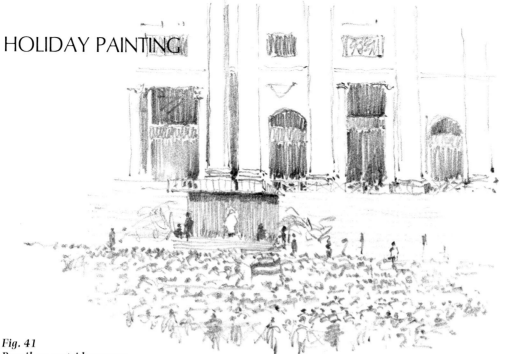

Fig. 41
Pencil on cartridge paper.
16 minutes

Fig. 43
Watercolour on cartridge
paper.
40 minutes

wide steps that lead up to the Basilica was a raised platform shaded by a canopy. In the middle of this platform stood a white-robed figure – the Pope. What an opportunity!

I literally ran to the barriers and started to sketch (fig. 41). I drew the platform and the figure of the Pope first – in case he left suddenly. I was thrilled with this sketch: it is a once-in-a-lifetime work.

Inside St Peter's Basilica the massive structure was bathed in warm light and soft colours from floor to ceiling. As soon as I saw the view in fig. 42 I just had to paint it so I found a quiet spot and stood, leaning against a marble pillar.

I started the drawing with the gold window – the important element – at the top left-hand side of the paper to establish its position, then completed the scene.

Again, the window was the first to be painted and the area below it, which I worked very freely. I painted to the right of the two columns with free brush strokes of delicate warm greys. I put in the two black columns, the figures and, finally, the reflections on the marble floor.

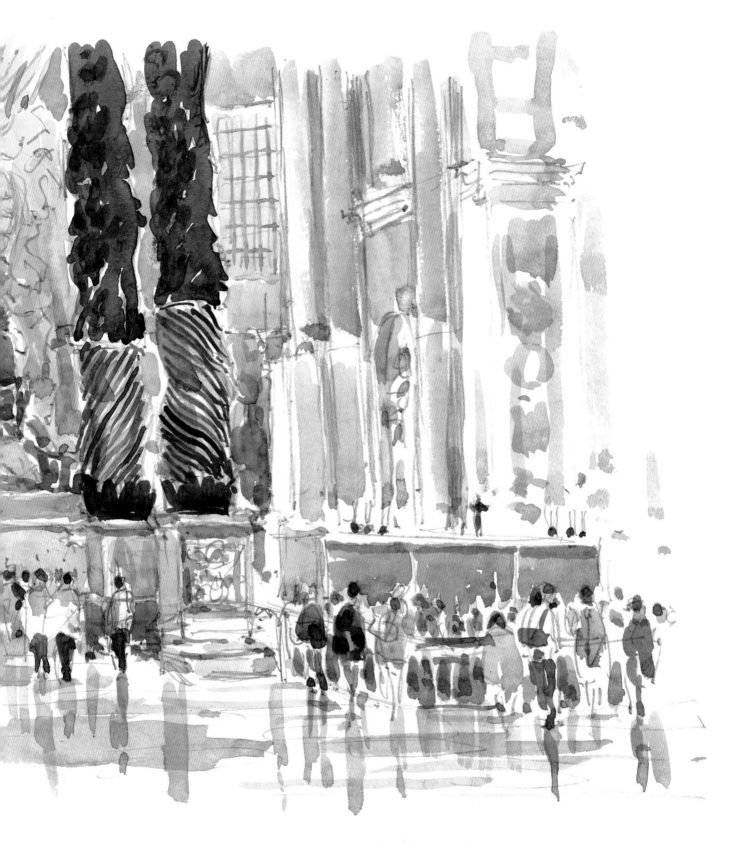

There is a wonderful view over the roofs of Rome from the top of the Spanish Steps (fig. 43). I drew the skyline, then shaded it with a 2B pencil. Next, I drew in the nearest roofs but didn't put in any detail because I felt this would have spoilt the simplicity of the painting.

I painted over the pencil sketch and when this was dry I put three separate washes of warm ochre colour over the whole picture to help to create a late afternoon feeling. The fact that I was looking into the sun gave to the scene an appearance of melting tones and colours.

We enjoyed this holiday very much. I made 25 sketches in pencil and colour without allowing painting to govern the trip.

Fig. 42
Watercolour on cartridge paper.
40 minutes

LIMITED CHOICE

One of my old painting haunts is Trigg's Lock on the River Wey in Surrey. On a return visit one morning, when the clouds threatened to cover the sun within an hour or so, I hurriedly got my oil-painting equipment out of the car – only to find that I had forgotten my chair. The ground was wet and muddy and it was a considerable time before I found a convenient mooring post to sit on.

My imagination was caught by the receding tones, the subtle sunlight on the church tower, and the contrast of the willow tree, all of which were created by

the sun being in front and to the right of the picture (fig. 44).

I worked on Whatman 200 lb Not paper primed with three coats of Acrylic Primer. I drew in as usual with a turpsy mix of Cobalt Blue and Crimson Alizarin. I painted the sky very thinly and then worked down into the hills, church and green fields. The colour of the fields surprised me, as they were very bright green. This, of course, helped the silhouette of the willow tree to look dark and solid. I was very pleased with this painting because of the subtle middle-distance colours and tones, although I feel

Fig. 44
Oil on Whatman 200 lb Not.
35 minutes

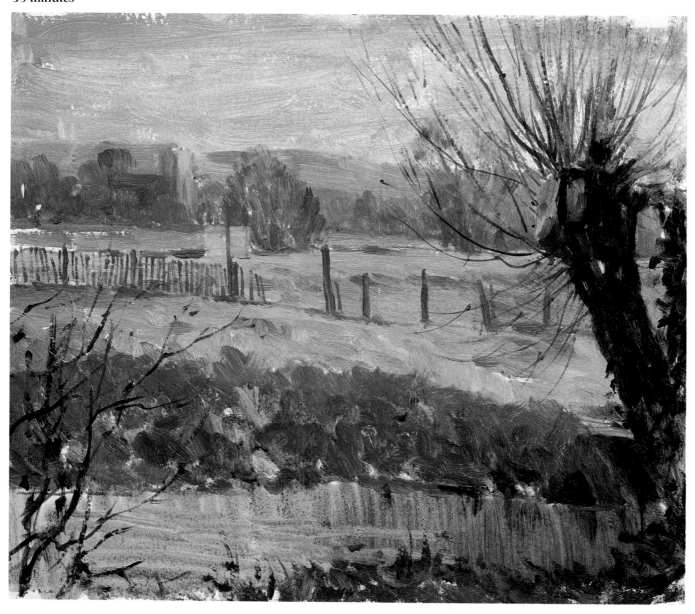

that the muddy backwater in the foreground could be a little darker.

My next subject (fig. 45) was a little ambitious for a half-hour oil painting, but there were no more seats around so I had to find a subject from where I was perched. It was a complicated subject to draw – the cottage, lock gates and bridge, with the tow-path receding from me. I began on prepared Whatman 200 lb Not paper with a turpsy wash for the sky, then I painted the silhouette of the cottage, then the lock gates. By now, the sky was dry enough to dry-brush in the distant trees. Then I

worked on the garden area in front of the cottage, and the willow tree. Finally, I painted the path and grass, using the paint thinly.

I always recommend that, where practicable, all brush strokes should follow the direction in which something 'goes or grows'. This helps to show form and direction. The trees in the background of this painting, and the path and grass, are good examples.

Fig. 45
Oil on Whatman 200 lb Not.
40 minutes

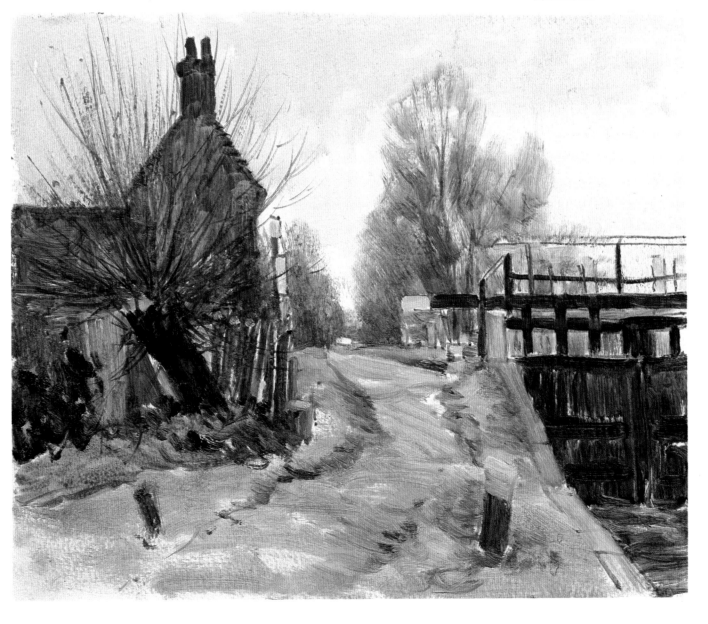

COMPLICATED SCENES

Another day, another local trip, and a mist came from nowhere, almost blotting out the sun. Perhaps it was the subtlety of the soft tones against the dark strong tones of the muddy path or the intricate tangle of trees that inspired me (fig. 46).

I painted this oil on prepared Whatman 200 lb Not paper. After drawing in with Cobalt Blue mixed with Crimson Alizarin, I painted the sky with a turpsy wash of the same colours. I scumbled very dry paint in the background and tree areas, and over the top of this I painted in the trunks and branches of the trees. This painting went just right from the very start. I feel that it is one of my best paintings in the book.

In fig. 48 is Harpford church, which I have painted on quite a few occasions from different viewpoints. On this particular afternoon, with a lot of hazy spring growth in front of the church and the angular tracery of the apple trees, it looked complicated enough to make a three-hour painting. But I liked it so much that I decided it was a challenge.

I painted very thinly on prepared Whatman 200 lb Not paper, but this is not the only way to do a painting in half an hour. If you find that using the paint thickly gets you there in time, then do it your way.

I left the sky and water as white paper and used this as my key for the brightest area of the painting, and the dark of the main tree as the darkest tone. I painted this in dark when I drew the picture. I worked very freely down the picture from the distant trees to the water. Then I drew over them with a rigger brush and suggested the apple trees and the small branches on the large tree. The sunlight catching the church was put on with thicker paint. I was very pleased with this painting, although it did take longer than the half-hour limit.

Fig. 46
Oil on Whatman 200 lb Not.
34 minutes

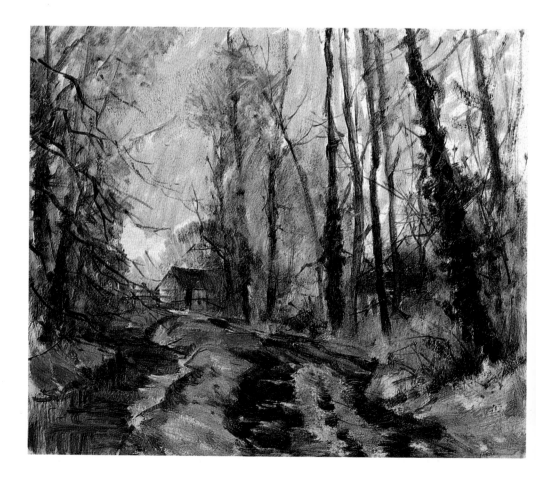

Fig. 47
Alwyn Crawshaw painting the
scene in fig. 48 below

Fig. 48
Oil on Whatman 200 lb Not.
40 minutes

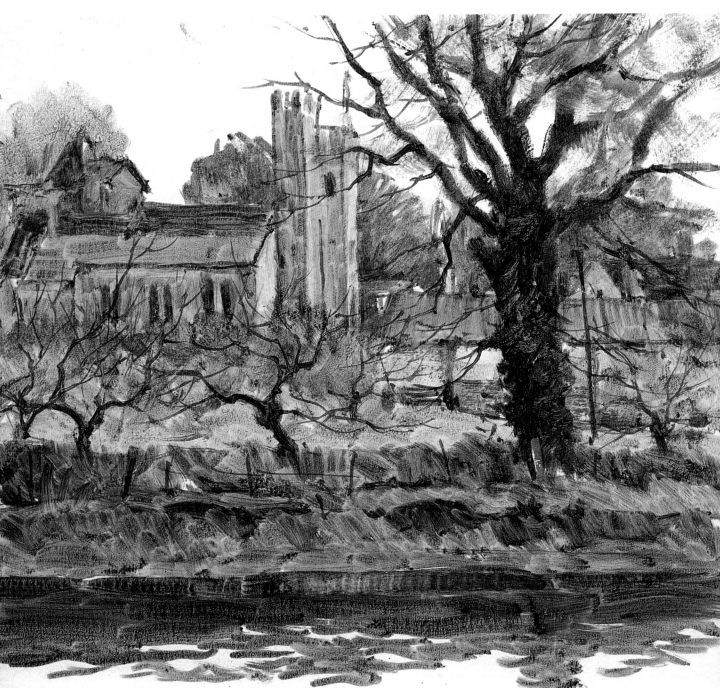

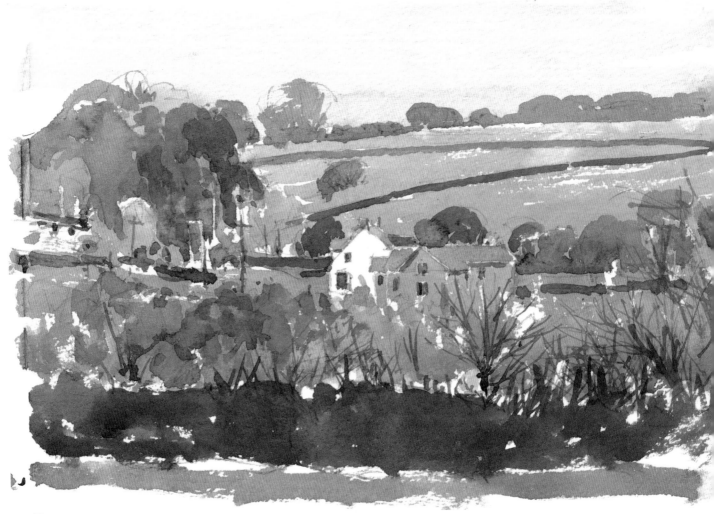

Fig. 49
Watercolour on Bockingford
200 lb.
28 minutes

Fig. 50
Pencil on cartridge paper.
20 minutes

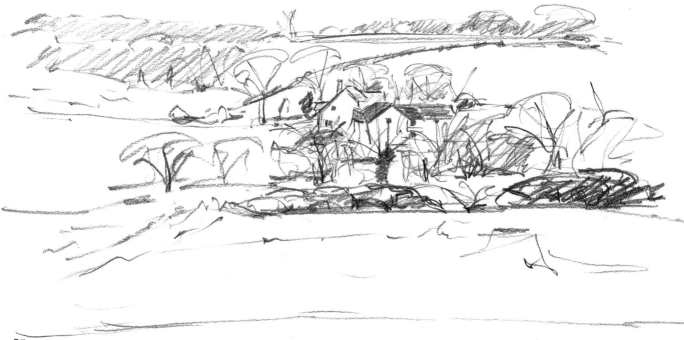

LANDSCAPES WITH BUILDINGS

The warm brick colour of the house, contrasting the white house next to it, was the inspiration for the painting in fig. 49. Over the hedge, the trees appeared to be melting together with the fields directly behind them in a haze of warm greens and browns, with the houses growing out of it. It was important, then, to make sure that the houses had a definite shape where they were clear of the trees, and their windows became an important feature.

June had remained in the car and decided to do a pencil sketch on cartridge paper of the same scene (fig. 50). All artists see and interpret a scene differently. June has a natural tendency to flatten and extend a landscape, while I make objects slightly higher or larger than life. In representational terms, June's pencil sketch and my painting are different, but they are both 'correct'. It is the way we see.

After working in the studio for the rest of the day, we found the evening light was too good to miss so we went down to the river. I had intended to paint the river, but looking at the farmhouse in fig. 51 with the low evening sun casting long shadows and exaggerating the red of the Devon soil, I just had to paint it. Later, I felt that the foreground ploughed field could have been quite a bit darker. This would have helped the two ploughed fields in the middle distance to recede. But I do like the outbuilding, farmhouse and trees on the right, with their long shadows.

Look at the trees to the front and right of the farmhouse, where there is a suggestion of tree trunks. This was done very loosely by leaving the first wash showing in 'trunk' shapes as I painted the dark hedge in front of the house – a very subtle but important feature to the painting.

Fig. 51
Watercolour on Bockingford
200 lb.
25 minutes

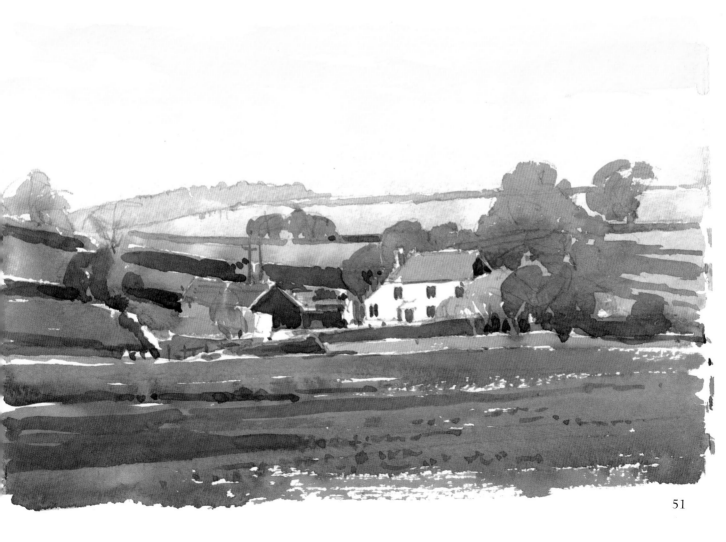

BOATS AND WATER

There was one spot in the old sea port of Topsham that I particularly wanted to paint, down near the old wharf. When I reached it the road was closed for repairs so, in spite of the complicated subject, I settled on the view in fig. 52.

The most important thing to get right was the drawing: in particular, the roof of the building with the chimney, and the flat-roofed building to the right; the large red-and-white yacht and the grey boat to the left of it, and the two rowing boats in the centre of picture. I was very pleased with this one, especially when I finished it only nine minutes over the half-hour, which also included a skirmish with the grandchildren, who came with me.

The old lock-house (fig. 53) worked well; it was just the subject for watercolour, with strong contrast and definite shapes. In front of the three yachts were four more but I decided to leave them out because I would have lost the simplicity of the water.

Do not make a habit of taking objects out of nature because you don't know what happens to the 'missing' landscape and you could substitute something that is totally wrong. I had no problem in taking out the yachts because only water was left, and I treated it very simply.

The view in fig. 54 intrigued me, because the buildings in the middle-distance must have been at least a mile away and all I could see in front of them was a large expanse of rushes that came down to the river's edge. Could I make the church and buildings look that far away, without the help of receding objects? The distant church tower I exaggerated a little to help the eye go through the picture. On reflection, it may be just a little too large. I didn't over-work the two yachts, and I added a few simple brush strokes of warm grey to suggest water.

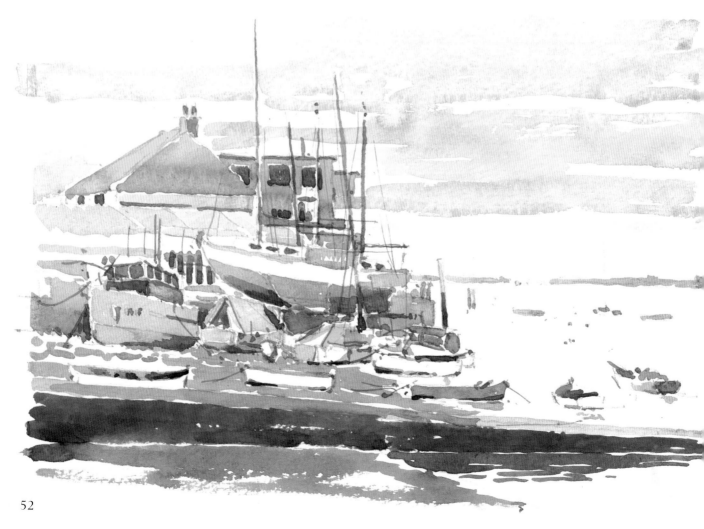

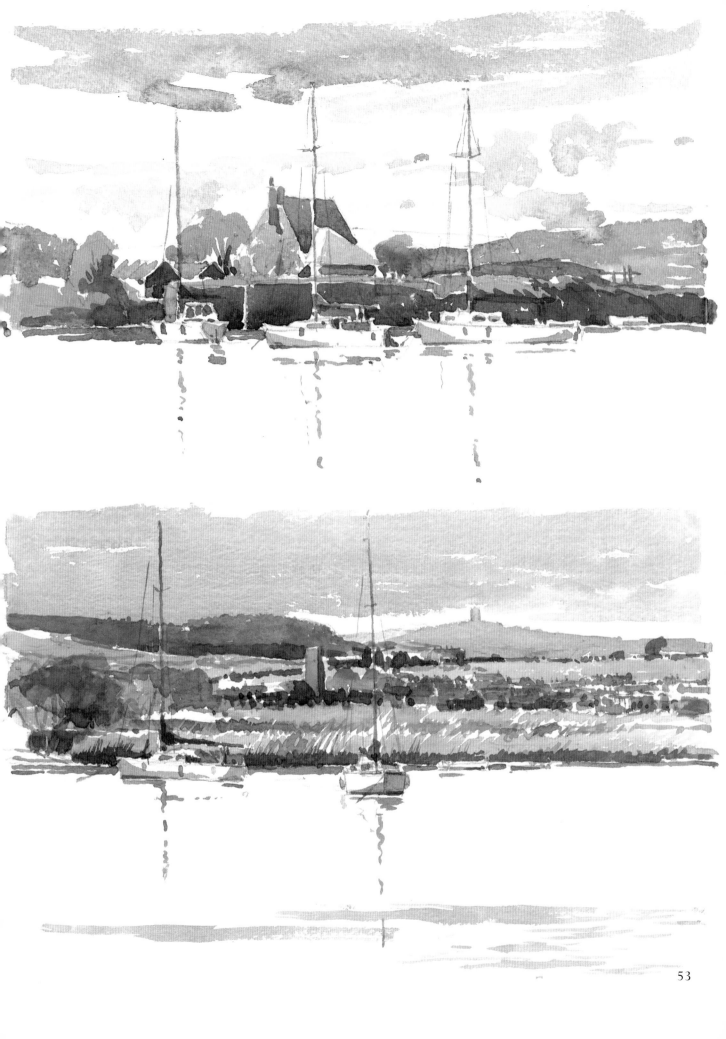

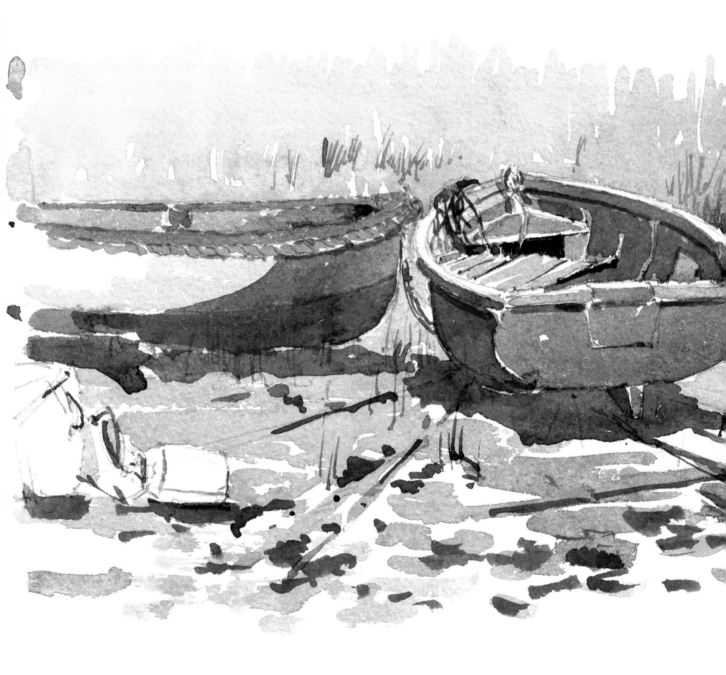

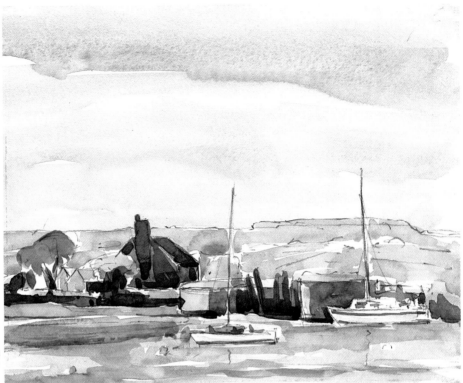

After lunch I picked out a couple of rowing boats (fig. 55) because of the light reflected on the foreground mud and the strong shadows. The drawing was important and I took 15 minutes to complete it.

Above the boats I painted the rushes very simply, and above them I could see the water. This I left unpainted. By not over-working, I have drawn attention to the two boats. I was surprised just how dark the shadow was on the old white boat on the left. Any white object can be very dark in a shadow area.

Then I relaxed. This half-hour painting certainly keys you up and puts the pressure on you. I did some pencil sketches of the ferry and some boats in my own time.

While I was doing all this, June was painting the lock-house (fig. 56), as I had done earlier that morning (fig. 53). She worked from a different viewpoint and on cartridge paper, which is good for quick, small paintings. Her painting has the characteristic 'cartridge paper' look. I like the strong shadows on the lock-house and lock gates.

Looking at our two paintings side by side, I see that I forgot to paint the furthest range of hills. If you look closely you will see my pencil line, to the right of the lock-house. You can almost accept this omission in a half-hour painting, but when you are painting under normal conditions, then you should check your real-life scene against your work all the time.

Fig. 56
Watercolour on cartridge paper.
30 minutes

Fig. 55
Watercolour on Bockingford 200 lb.
32 minutes

SUNLIGHT AND SHADOW

Genuine inspiration or excitement about a scene will always result in an extra-special painting and, of course, an extra-special feeling of achievement.

To me, this harbour scene (fig. 57) was one of those specials. The inspiration came from the dark silhouette of the church, houses and trees, and the contrast of the sunlight on the yacht and grass bank. I took care in drawing the church and boat, but the painting was done very freely, leaving white paper to suggest strong sunlit areas. While I was painting the dark buildings, I accidentally splashed paint on the sky to the left of the church. The sky

was still wet and I did a stupid thing: I tried to wash it out. How many times have I told students to wait until it dries and then try to get it out with a wet clean brush! The result was what I should have expected: a washed-out area. In this case it looks like a cloud that has appeared in a cloudless sky. Even so, the painting is one of my favourites. I captured what I set out to achieve – sunlight and shadows.

After a break for lunch, I started the painting in fig. 58. The dark shadows on the buildings and sea wall and the tall chimney attracted me to this scene. Also, moored there was a new boat, the one on

Fig. 57
Watercolour on Bockingford 200 lb.
35 minutes

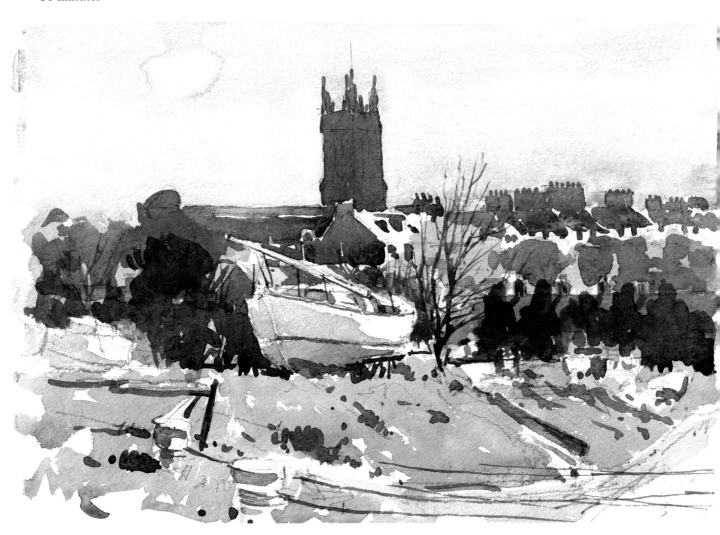

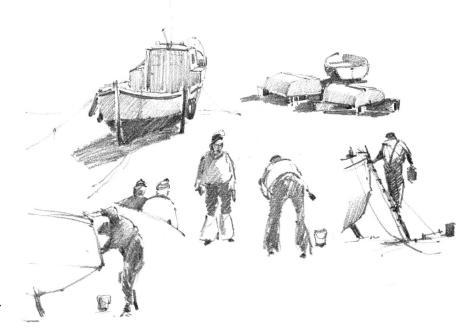

the right of the picture, and I liked its shape and colour.

The drawing on this one was again important. If you are going to paint in a representational way, the more detail you want to put into your picture, the more skilled you have to be at drawing. But you must also get your tonal values right. Drawing and painting are partners working together.

I was happy with the effect of sunlight I achieved in the painting, but the boat on the right was drawn a little too short; the hull should have been longer. I did find this painting hard to work within the time-limit.

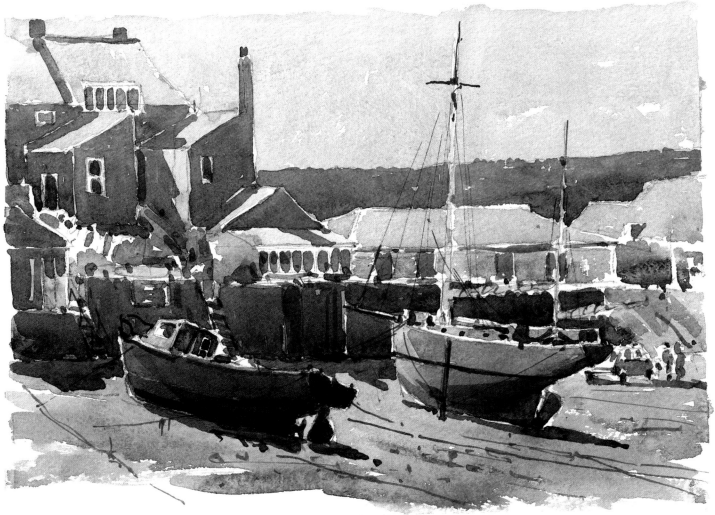

Fig. 58
Watercolour on Bockingford
200 lb.
40 minutes

Village scenes

Fig. 59
Langdale from the quarry.
*Watercolour on Bockingford
200 lb.*
31 minutes

Fig. 60 opposite above
*Watercolour on Bockingford
200 lb.*
40 minutes

Fig. 61 opposite below
*Watercolour on Bockingford
200 lb.*
39 minutes

A very dull and misty afternoon heralded our arrival in the Lake District, where June and I were to stay with friends in the beautiful village of Elterwater. However, our hosts, Colin and Audrey, assured us that the weather would be good, or at least it would not rain, for the first painting trip next morning.

That evening we all went for a walk so that I could get the 'feel' of the place, and to see whether I could find any good spots from which to paint. In a quarry I did spot an old water-pump that looked very attractive, and I decided it would make a good pencil sketch. I would be back!

Next day, we awoke to a gloriously sunny morning. My first painting was *Langdale from the Quarry*, fig. 59. This slate quarry has been used for over a hundred years and is still worked today. When I first saw the scene it looked like the painting, with dark mountains in the background, light ones in the foreground with dark trees. After I had started to paint, the light completely changed. It was too late to change course and so my tonal values had to be remembered from what I had *observed* 10 minutes previously. I was reasonably happy with the result.

In the quarry, I was fascinated by an old wood and corrugated iron building (fig. 60). I simplified the hills and fields behind to keep the interest on the building. The telegraph poles and wires, an important feature, are painted sympathetically, not with heavy dark lines which would have jumped out of the picture. Careful modelling on the front of the building, where the diagonal shadow cuts across the light surface, gives form to the complicated shape of the building. I was aware of making sure that I had enough foreground but I think a little more would have helped the composition. However, I was pleased with the painting. Drawing took 13 minutes and painting 27 minutes.

Naturally, before we went into the quarry area, we had obtained permission. It is almost an artist's unwritten law that, if possible, permission must be obtained whenever you paint off the beaten track.

During the afternoon, I worked from the village. Sitting on my fold-up seat on the small village green, I painted the houses behind Elterwater bridge (fig. 61). I started with a careful drawing, using a 2B pencil. The main foreground tree I painted up to – not over – in case I wanted to leave it as white paper, which I did in the end. In watercolour painting, some areas can be left unpainted and, if this is done sympathetically, it can give a painting character and life. The shadows came and went, so when they were there I either

58

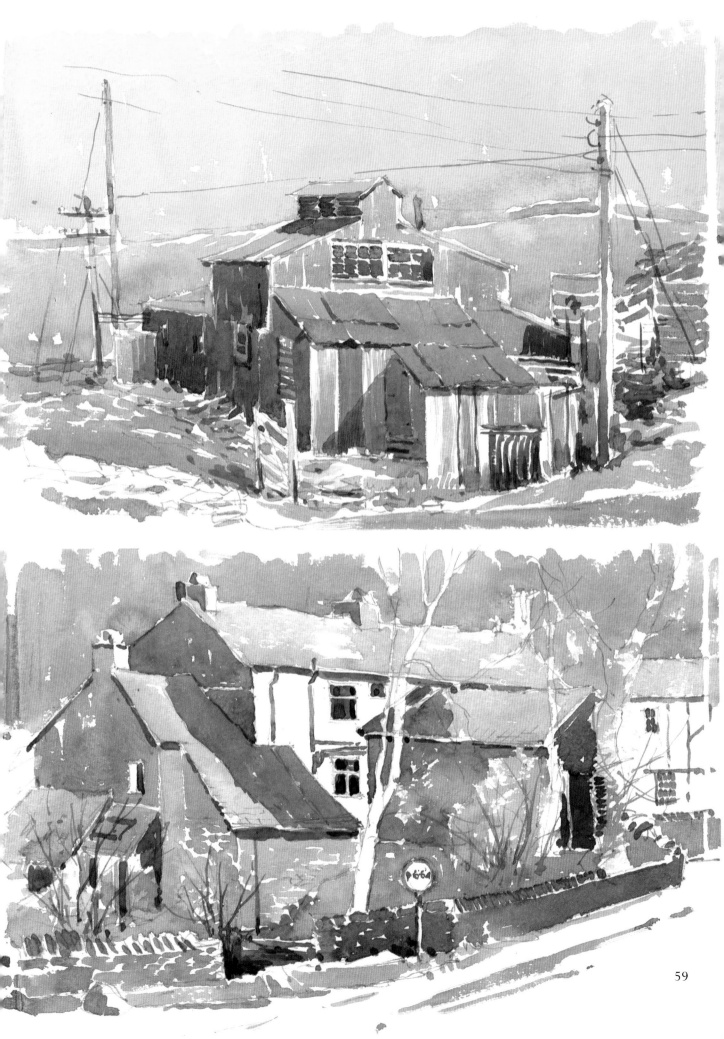

VILLAGE SCENES

drew them in or memorized them.

While I was in the middle of the painting, an old van coughed and spluttered up the road and broke down – right in front of me, obliterating half the scene! I carried on painting what I could see and it left just in time to reveal the rest of the scene and for me to finish the picture. I do like the road sign, which adds a modern-day look to the painting of an old-world building.

I walked over the road, through the gap in the wall (which can be seen in fig. 61),

sat on a rock, and painted fig. 62. The drawing was not complicated, but the arch of the bridge had to be observed and drawn correctly. Notice how much white paper I have left to suggest sunlight on the rocks on the left. The stones around the arch were painted in individual brush strokes, changing the colour as I went and letting some brush strokes join together, thus avoiding a precise, mechanical effect.

I saw the water as a very dark colour, as I have painted it, but when I looked more

Fig. 62
Watercolour on Bockingford 200 lb.
35 minutes

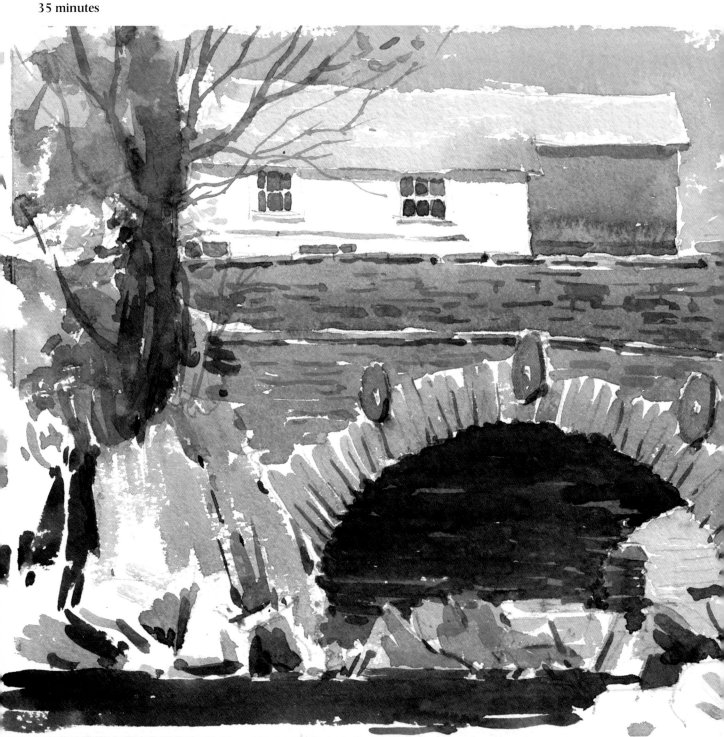

60

closely I noticed a slightly darker reflection of the underside of the bridge. Had I added a darker tone at that stage, it would have been too dark for the rest of the painting. I should have painted the water a little lighter first and then added a darker tone. The result would have given a better illusion of water.

Just as I finished the painting, two fighter jet aircraft flew over almost at roof-top level and frightened the life out of us all. Even in a picturesque and quiet country village like this, you can't escape from twentieth-century noises.

All I did was to turn round, and I could see the old shed in fig. 63. The sky, the hills and the trees in the left-hand background were done very wet and not strong in colour. This kept the distance in its proper place – in the distance. The roof of the hut had attracted me as it was a lovely soft green; this I painted very carefully. I was also careful to paint in the shadow on the wall to the left of the shed. The sun was coming from the right, and yet the right shed wall was darker than the front because it was built with a darker stone.

I kept the stream very simple as most of the water had light reflected on it. If I had had more time I should have used it to model the rocks on the bank and perhaps put in a little more work on painting the water. Even so, it makes an interesting watercolour and I am happy with it.

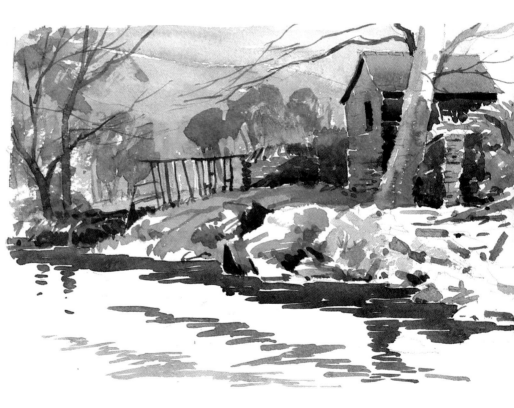

Fig. 63
Watercolour on Bockingford
200 lb.
32 minutes

VILLAGE SCENES

Fig. 64
Pencil on cartridge paper.
15 minutes

before I had started the first. Still, there is nothing better than enthusiasm, as long as it is controlled. So I sat quietly, relaxed, and looked at the scene (fig. 65).

The drawing had to be reasonably accurate, but it was not so important as a close-up drawing of one of the houses would be. There is some licence if a house is drawn a little longer or shorter than it actually is: the important point in the drawing is to achieve the correct proportions between the objects.

When you paint, the objective is an impression of the scene, and in half an hour this allows for no fiddling. See how the sheep were painted in the right-hand field. All I did was to paint a wash of green for the field and freely leave unpainted shapes (which again I had very freely drawn in pencil) to represent them. The windows were put in with one or two single brush strokes.

I started the painting with the sky, the hills and the buildings, followed by the fields, path and wall. With a second wash I worked the trees, making them darker, put shadows on the buildings and then added any details that I felt necessary. I particularly like the simplicity of the white houses on the right.

Then I turned round and decided to use cartridge paper for the scene in fig. 66. I had seen the large house, with its front face dark in shadow, as the important feature of the painting, with the white house on the left just coming into the picture to give some light relief against all the dark stone.

June was sitting nearby, painting the same scene, and she saw it quite differently (fig. 67). She made the white house the

That evening we went for a walk along the river. I had my sketchbook (cartridge paper) and I decided to stop and sketch Kitty Hall (fig. 64). I don't really know why, but I do like the car on the right.

As the evening was drawing to a close, we could see lights appearing in the village houses. Looking at the sketch now, I am taken back to that late evening, with its damp smell of a closing warm spring day, and I am sure I could use the sketch as a starting point for a studio painting.

Next morning, we sat on a wall running along the side of the river, which was flowing swiftly except where it gurgled and splashed over well-worn rocks and stones that broke its rhythm. I was mesmerized by the water and decided that after lunch I would find a spot to do an oil painting of just the water. I was becoming too excited, thinking about the next painting even

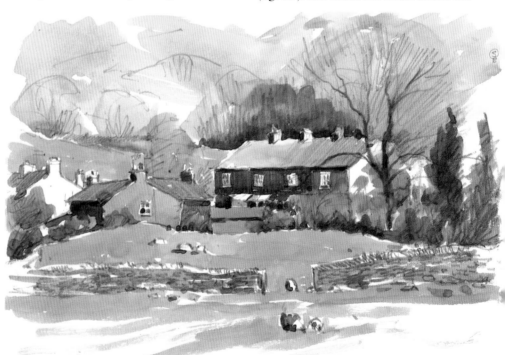

Fig. 66
Watercolour on cartridge paper.
29 minutes

62

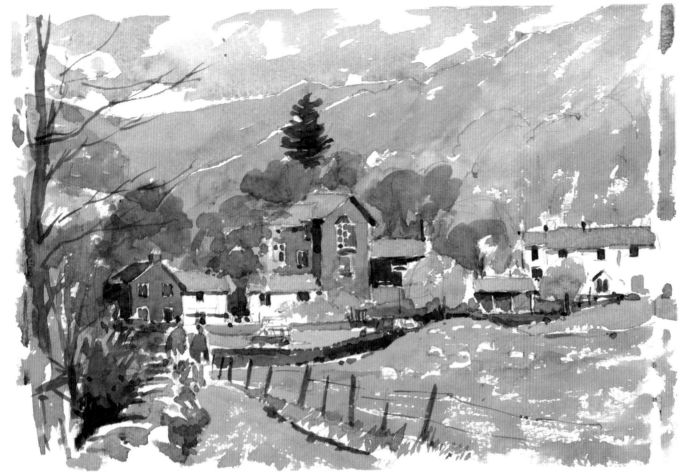

centre of interest – observe how much longer it is in proportion to the large house in her picture, when you compare it with mine. June has also exaggerated the steepness of the hill – or have I flattened it too much? Who knows? It really doesn't matter. I do like the sunlight that June has captured in her painting, and her warm colours. She took 43 minutes, but hoped she would do better next time!

Fig. 65
Watercolour on Bockingford
200 lb.
35 minutes

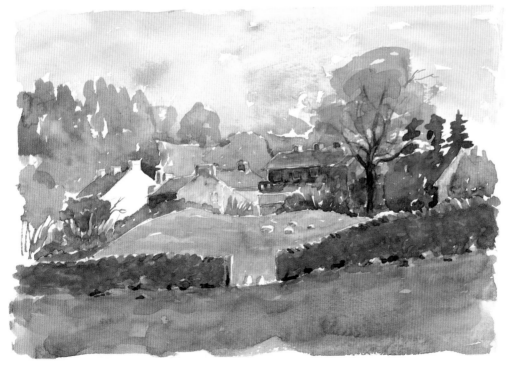

Fig. 67
Watercolour on Bockingford
200 lb.
43 minutes

VILLAGE SCENES

Later, we found a place where I could get near to the water's edge for my oil painting (fig. 68). Working on prepared Whatman 200 lb Not watercolour paper and using my No. 6 sable brush, I drew with Cobalt Blue mixed with plenty of Low Odour Thinners.

I painted the reflections of the bank and trees with the same mix but adding Yellow Ochre and a little Crimson Alizarin. Then, between the reflections I worked in the warm yellowy-brown colours to represent the stones on the bottom. After that, I painted the landscape above. I feel that the grass is a little too strong in colour, but it doesn't bother me too much.

While I was painting the water, two cows appeared over the brow of this hill, in a perfect position to give a little life to the picture. After noting their positions and size in relation to the trees, I decided that I would put them in at the end. I couldn't do it while I was in the middle of painting the water. As you can see, I completely forgot! Some say it's old age; I like to think it's because I was too concerned about June falling into the river, as she was perched precariously at the water's edge, painting me doing this picture (fig. 69).

I used a very pale blue for the light-coloured water, which was reflected light from the sky, and I was most disappointed with it; the water was a disaster. Carefully observing the water again, now I could see the blue as a 'creamy blueish-green' – I can't explain the colour better. When I mixed Titanium White, a little Cobalt Blue, and a little Yellow Ochre, and painted over the first blue colour, I was very pleased with the result.

Fig. 68 right
Oil on Whatman 200 lb Not.
42 minutes

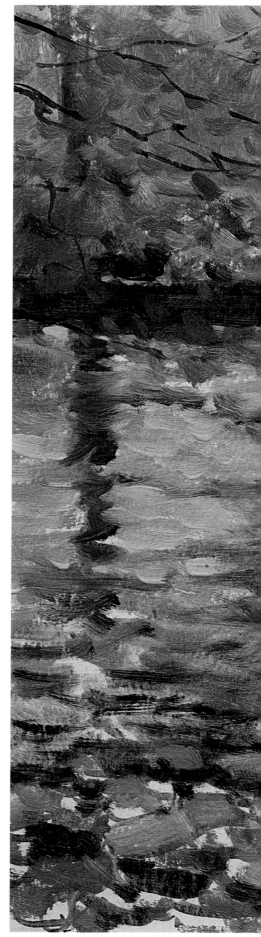

Fig. 69
Watercolour on cartridge paper.
35 minutes

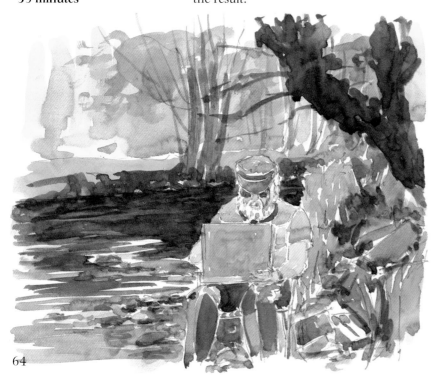

64

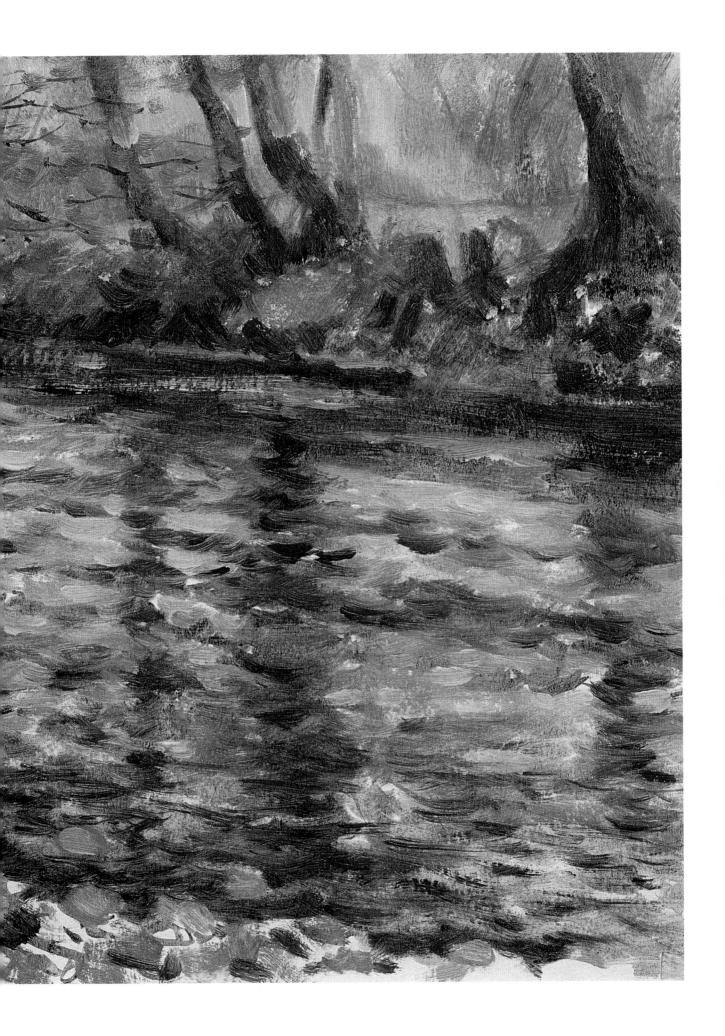

VILLAGE SCENES

In the evening we decided to go for a walk up to the quarry, where I would do a pencil sketch of the old water-pump that I had seen on the first evening.

The strange thing is that we couldn't find it. After a long search, we did find a water-pump but I was adamant that this was not 'my' pump. This one was held up by two horizontal metal girders, it was very functional looking and, more important, it would not make the type of drawing I wanted.

We looked around the area and finally returned to the pump; it was the only one. I couldn't believe it. This must have been the pump I saw the previous evening. Which confirms my advice: when you see something you like, paint it.

Now the sun was low, giving a strong, warm evening light. The two horizontal girders were in full sunlight and these dwarfed the upright section of the pump, which had some modern adaptations fastened on to it and didn't look very artistic. When I first saw it, it was in poor light, with no shadows to show form: I hadn't even noticed the two girders supporting the pump. I had let my imagination take over and my visual memory had elaborated even more.

Audrey, our ever-helpful hostess, told me that there was an old pump in the village itself. It proved to be a beauty (fig. 70). It had been there for over a hundred years and it looked like it! There was nothing straight or square about it; I couldn't have found a better one.

On the way back we passed the village letterbox, built into a stone wall. I used a 2B pencil on cartridge paper, and painted over simple watercolour washes (fig. 71). But after 15 minutes I had to give up because it was almost dark. When I saw this sketch indoors I was surprised how light the colours were. Because of the failing light everything had looked much darker outside.

Fig. 70
Pencil on cartridge paper.
15 minutes

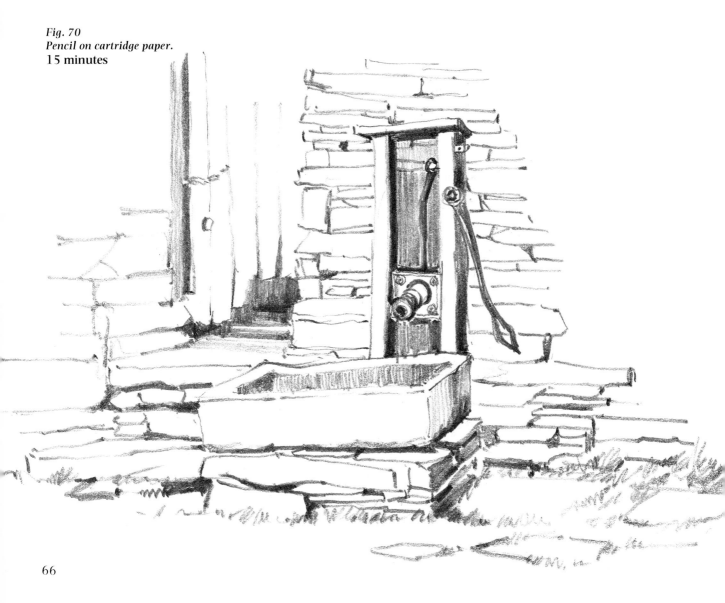

66

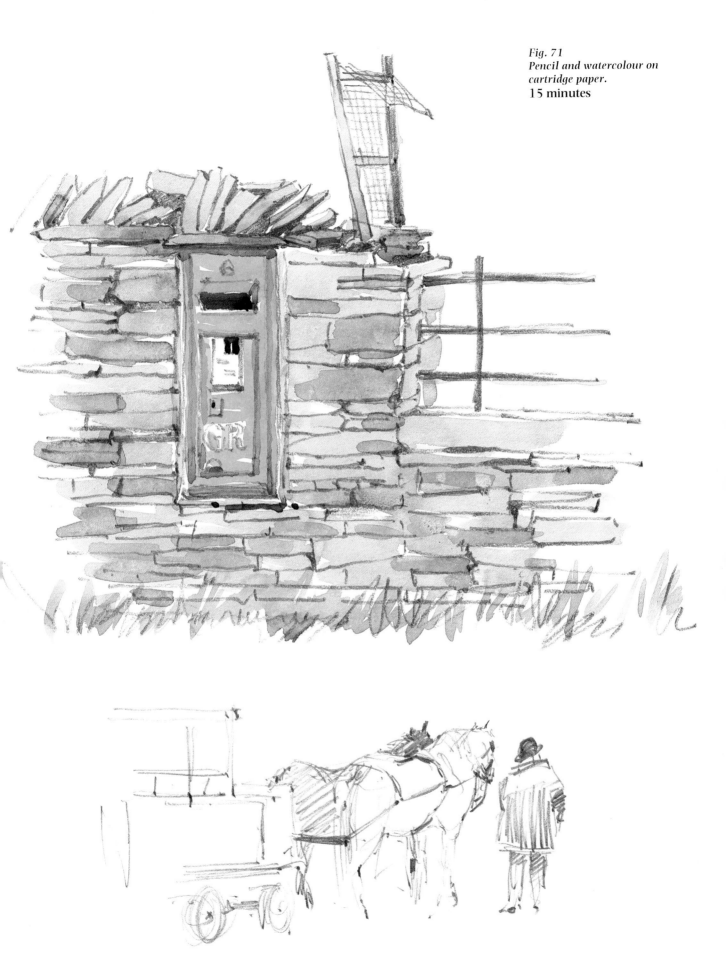

Fig. 71
Pencil and watercolour on
cartridge paper.
15 minutes

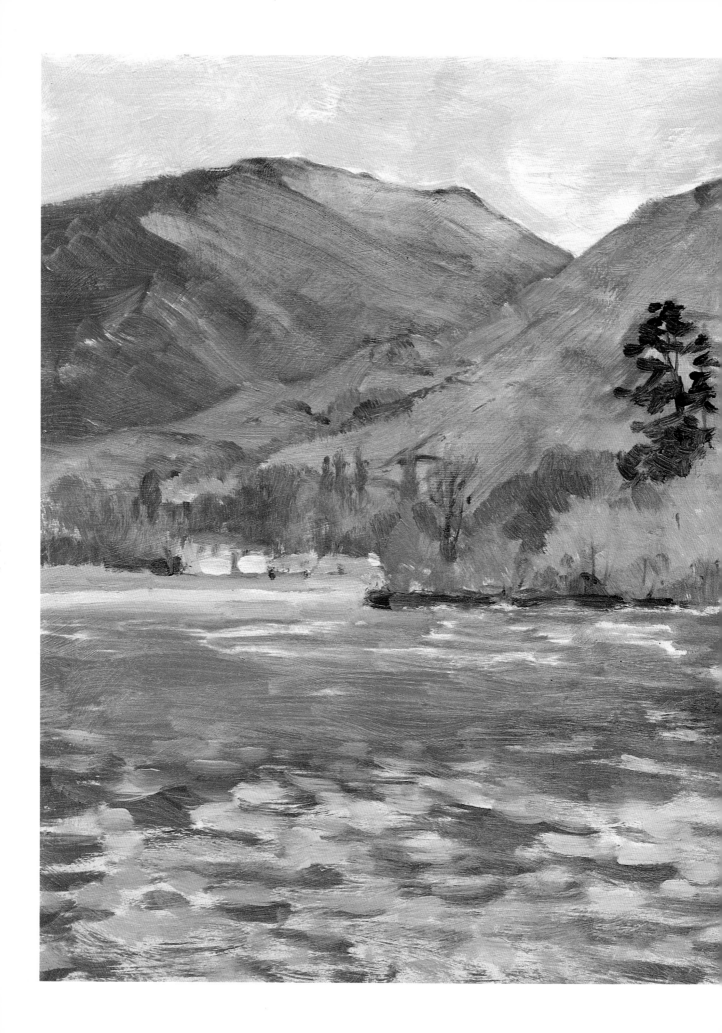

LAKES AND MOUNTAINS

We decided to go to Grasmere the following morning, and to row a boat over to the far bank, where I could paint the island with the mountains in the background (fig. 72). I did this on primed hardboard. I drew with Cobalt Blue mixed with Low Odour Thinners as usual, and thinly painted the mountains first. The mountain tones stayed generally the same, but the water was a menace. It was changing character every few minutes. The only way to cope with it was to observe its fickle moods, decide which one to paint and then go ahead. Preoccupied with the water, I did not notice, until I had finished the painting, that the left-hand end of the island is not sufficiently well separated from the distant land mass. Apart from this, I was happy with the painting.

The landing-stage that I sketched in fig. 73 while we were having lunch, is the one that we set off from in the morning.

Fig. 72 left
Oil on hardboard.
45 minutes

Fig. 73
Pencil on cartridge paper.
12 minutes

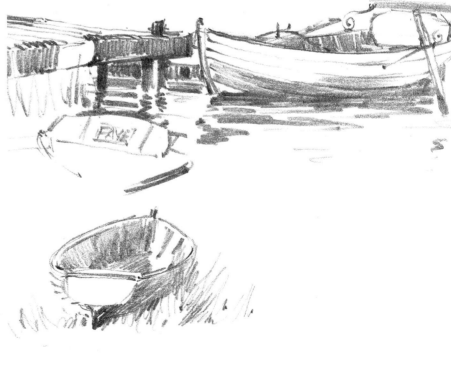

Fig. 74
Pencil on cartridge paper.
8 minutes

69

LAKES AND MOUNTAINS

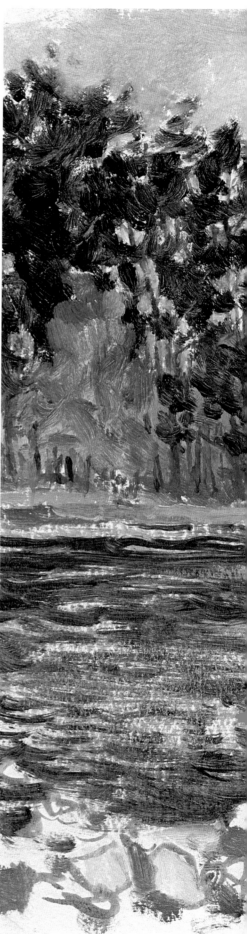

Fig. 75 right
Oil on Whatman 200 lb Not.
37 minutes

In the afternoon, we drove to Derwent
Water. A mist had developed and the wind
had dropped quite considerably although,
as is usual on a large lake, the water was
frequently changing mood.

I was inspired by the colour of the distant
mountains. The mist had taken all the
strength and colour out of them, and yet
you could see a solid mass. In fig. 75 notice
how, when I was painting the water, I
made some downward brush strokes to
create a 'reflection look'. I finished the
water with horizontal strokes but allowed
some of the vertical strokes to show.

I put in the fir trees next, then their
reflections, and the foreground rocks. I was
amazed to see just two people and one
yacht positioned perfectly for my painting:
it looks so like a nineteenth-century scene.

Fig. 76
Pencil on cartridge paper.
12 minutes

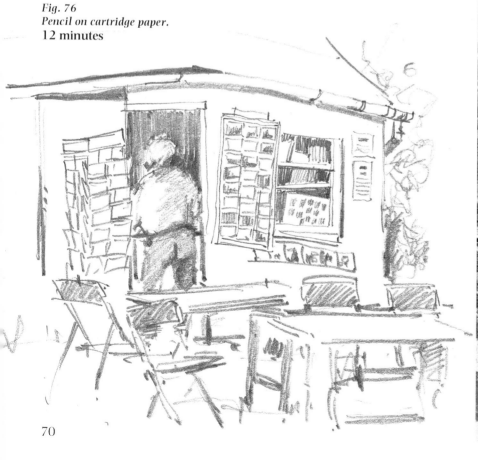

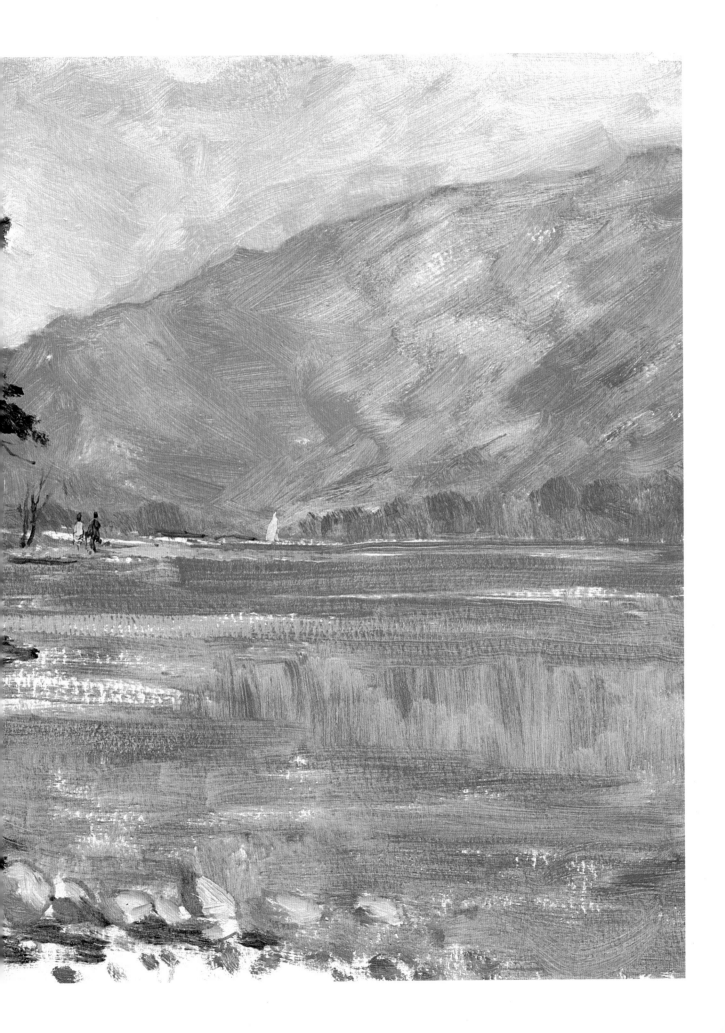

CAPTURING ATMOSPHERE

Next day, at the top of the Blae Tarn Pass, I painted the Langdale Pikes (fig. 77) from the car, as it was raining. I did this in my cartridge paper sketch pad, with a 2B pencil, shading in some of the tones and then painting over with watercolour. I was intrigued by the unusual visual effect of the scene. The mountains, wall and traffic sign all point upwards, one behind the other, creating a strange but likeable design.

Some walkers passed occasionally and I made a point of putting one of them in, to help give scale and add a little life to the picture.

I painted the picture in fig. 78 on prepared hardboard. By now it had stopped raining. The light was very soft and the background mountains were still covered in a thin mist but there was soft sunlight on the nearer hills. The fir trees were there again to help to create distance and also to give some local character and form.

I didn't find it an easy picture to paint in this light. All the receding planes were flat,

uninteresting, and lacking strength of tone and definition. You may feel that you want to create more strength in a painting such as this. However, remember that you are trying to paint the atmosphere of a particular moment and so it is better to paint what you see, not what you would like to see. You will then capture the mood of that scene.

When I had finished, I put the painting on my chair, still in the pochade box, to view it from a distance. The wind came from nowhere, without warning, and blew my seat over, sending the box crashing to the ground. I was lucky that the painting landed wet-side up, but its right-hand side was liberally splattered with turps. I can see where it moved the paint, although it hasn't ruined the painting.

On the way home, we stopped and I drew the sketch in fig. 79. On my next visit to the area I shall do some larger paintings because I feel some of the scenery requires a bigger format to do it justice.

Fig. 77
Watercolour on cartridge paper.
31 minutes

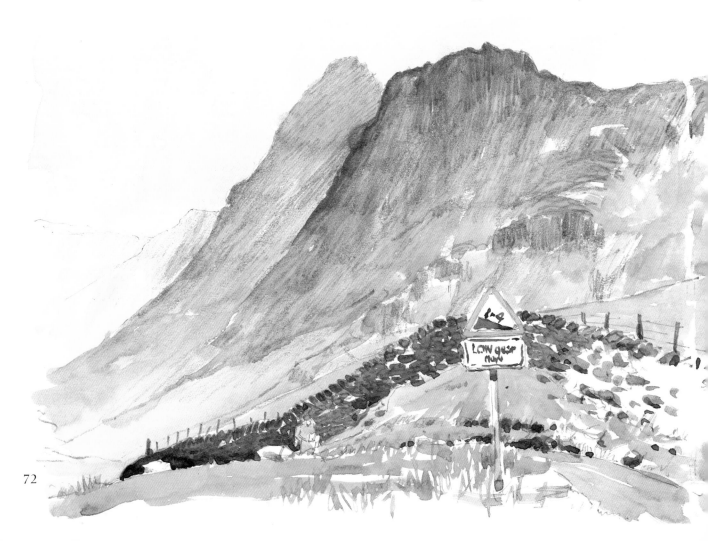

72

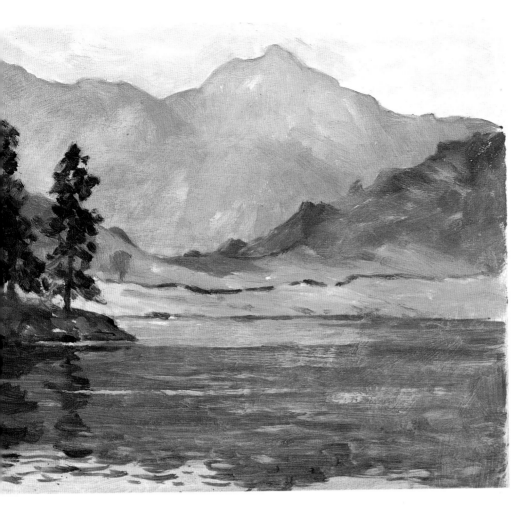

Fig. 78
Oil on hardboard.
40 minutes

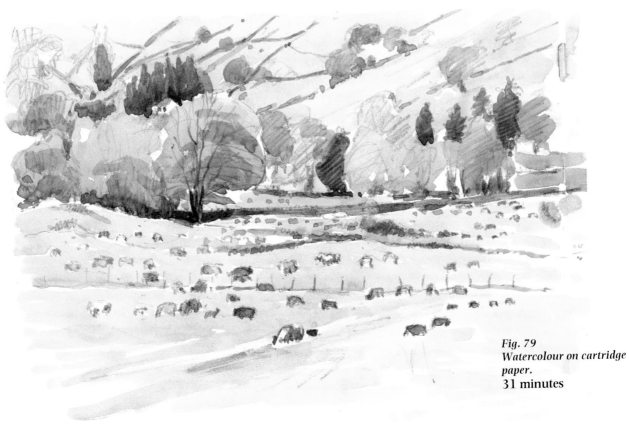

Fig. 79
Watercolour on cartridge paper.
31 minutes

73

A FAMILY DAY

Despite its vast spaces and mountains, when compared with some other mountainous regions the Lake District is small, cosy and friendly. But after painting there, I found I almost needed a refresher course for painting my part of Devon which, by comparison in size, seemed like a back garden. However, with the sun shining and a warm wind blowing, I left the

work I was doing in the studio, and set off with June, our daughter Natalie, and our two grandchildren for a walk down by the river.

We walked through a field full of buttercups towards an old derelict mill surrounded by trees (fig. 80). I painted simple colour washes over a pencil sketch. I used plenty of Cadmium Yellow Pale in the

Fig. 80
Watercolour on cartridge paper.
18 minutes

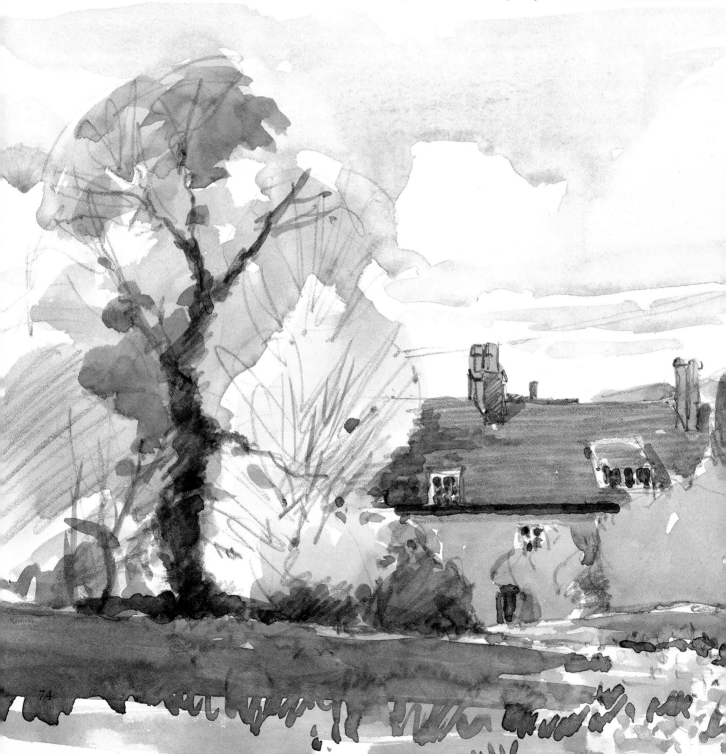

74

foreground field to suggest buttercups, but they looked too bright and sickly so I painted a dark shadow over them, starting from the left of the field. I was much happier with the result.

While I was doing this painting, June and the children were paddling in the river behind me. So I turned my chair round and decided to paint them next. When I work on moving objects, in particular animals and people, I observe the subject before starting to draw. I did the paintings in fig. 81 in half an hour, but at least 15 minutes of that time was spent observing and fixing in my mind a simple visual image of each character.

Whatever you do, don't go for detail. You are aiming for an impression. I drew all the figures first, using a 2B pencil (and a liberal amount of rubbing out), and then I coloured them with simple watercolour washes.

This was one of those memorable family painting trips. The sun stayed out, the children were good, nobody fell in the river, and I enjoyed my work and was pleased with the results.

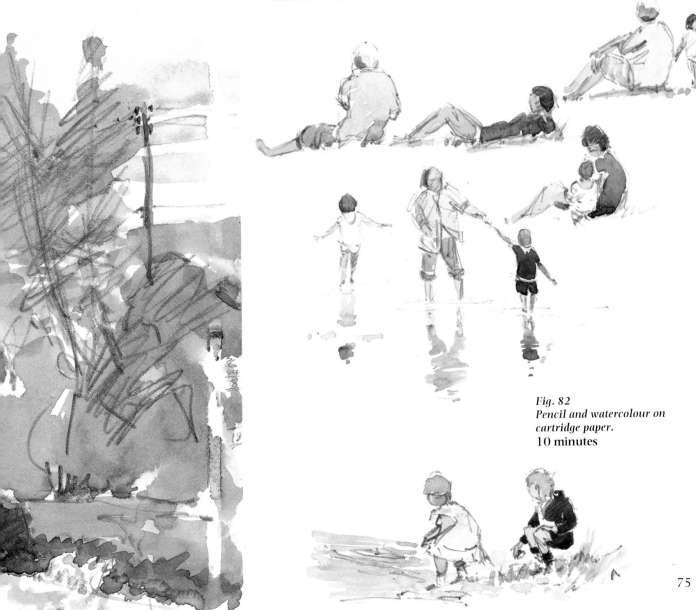

Fig. 81
Pencil and watercolour on cartridge paper.
30 minutes

Fig. 82
Pencil and watercolour on cartridge paper.
10 minutes

DIFFICULT CONDITIONS

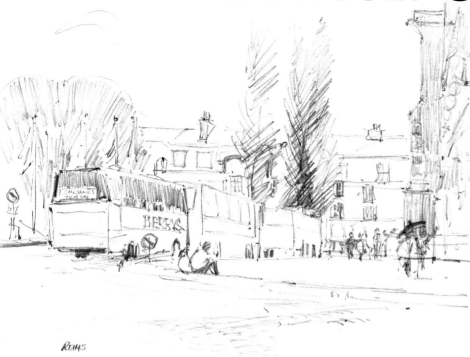

Rems

Fig. 83
Pencil on cartridge paper.
10 minutes

A five-day tour to France took us through the beautiful city of Rheims. After we had looked round the cathedral in all its Gothic splendour, I decided I had time for only a pencil sketch (fig. 83). When I had finished, the subject did look a little odd: a row of coaches, with the cathedral taking up less than a tenth of the picture! But with only about 10 minutes available I could not have attempted to sketch the front of that massive building.

On our way back from a visit to the champagne cellars of Moet et Chandon, our driver stopped the coach for a picnic. Here was a chance for a painting. I was lucky that the driver had chosen a spot where I could see the view in fig. 84. On cartridge paper I drew the village, which seemed to be sitting on top of a hill of grapevines. I love the pattern that the vines make, and the subtle red of the houses complementing the greens of the fields. The composition works well, but I am not too sure about the tree in the foreground, although it does help to give dimension to the foreground fields. Notice how simply the buildings are drawn and painted; also how much white paper I have left. The 'paper' lines left in the fields help to prevent a heavy and over-regimented appearance.

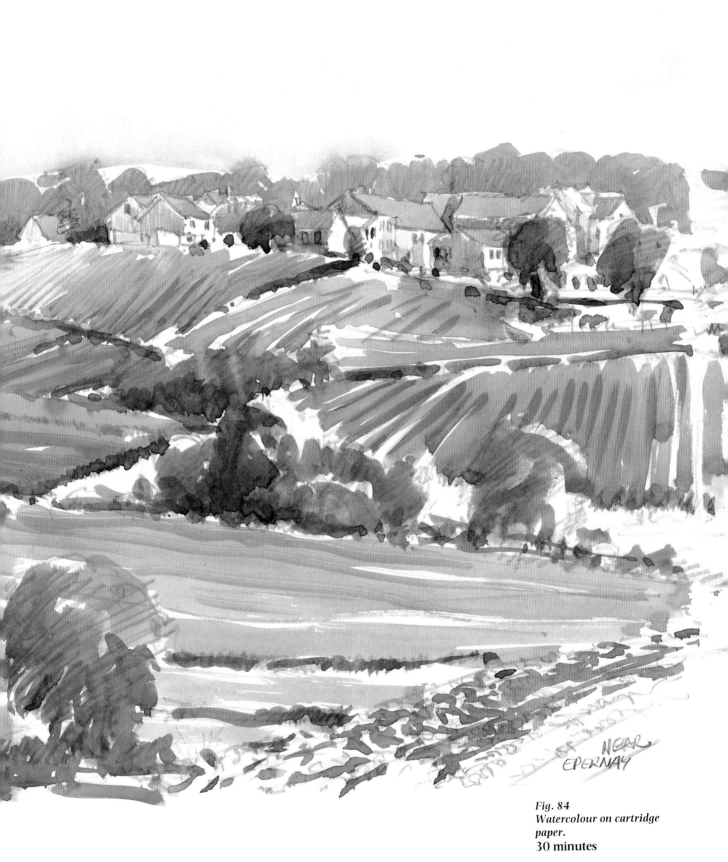

NEAR
EPERNAY

Fig. 84
Watercolour on cartridge
paper.
30 minutes

DIFFICULT CONDITIONS

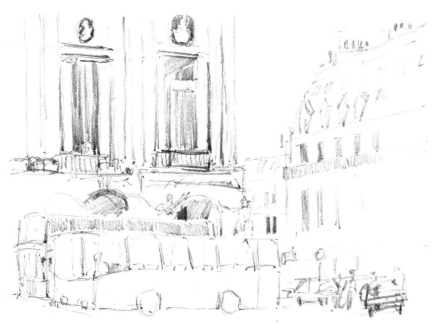

Fig. 85
Pencil on cartridge paper.
10 minutes

PARIS, PLACE de l'OPERA

CHANTILLY

The next day we were in Paris with some free time. We had a fabulous time in the Louvre, had a good lunch, came back over the river to do some sketching – and then everything went wrong. We couldn't get back across the Champs Elysées, which was cordoned off by the police, and there were thousands of people lining its pavements.

I decided that if we kept walking to the left, there must be a place to get across. The further we went, the more crowded it became. There were bands playing, TV cameras, radio vans, and even more people. The sun was out and it was very warm. Bright colour and strong light and shade made the whole scene very paintable. But we didn't have time to paint. We had been walking through crowds, trying to get across, for nearly an hour.

We then had a bright idea – go down the Métro and come up on the other side of the Champs Elysées. We found the Métro, went in, ran around inside like rabbits – and came up where we had gone in! We decided not to make matters worse, but to try another way. The only other way was by taxi, but this meant going further away still to find one.

It was at this point that we actually looked at the banners and posters around us and found that everyone was waiting to cheer the riders of the Tour de France to victory.

After several unsuccessful attempts we finally reached the Place de l'Opéra to meet our coach scarcely a moment too soon.

I started to draw the Opera House (fig. 85) when two coaches came and parked in front. It wasn't my day. So I drew the coaches.

Minutes later our coach arrived and we were taken to Chantilly, where we visited the Equestrian Stables and Museum. We had just about got over our afternoon and were actually laughing at it, so I relaxed and watched and sketched the horses as they displayed various stages of dressage. I drew (fig. 86) on cartridge paper with a 2B pencil. I added colour when I arrived back at the château an hour later and I have included painting in my time. Notice how warm the colours are. This is obviously because of the warm stone colour and the red-pink colour of the dressage ring, but also because it was early evening, when colours grow warmer as the sun descends.

The pencil sketches in fig. 87 took about five or six minutes each. I did these as I walked around the stables before we left.

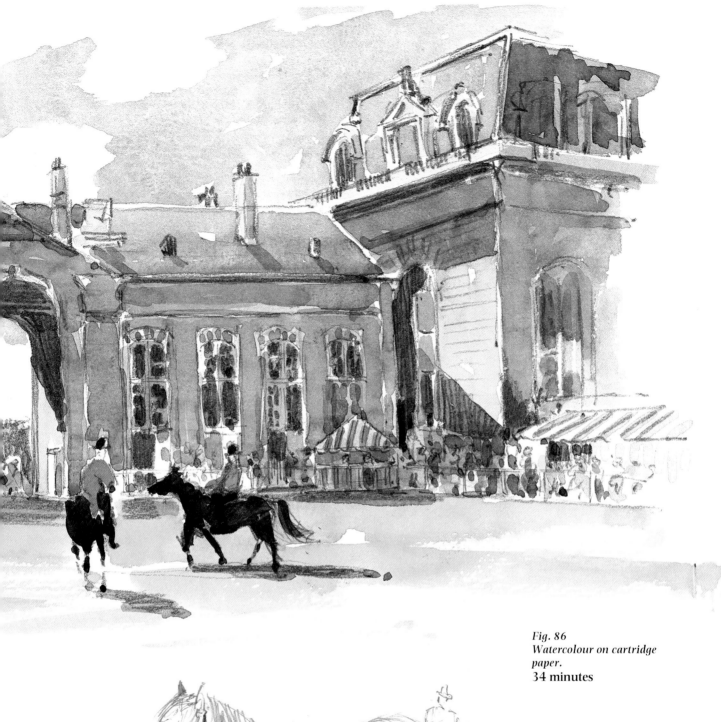

Fig. 86
*Watercolour on cartridge
paper.*
34 minutes

Fig. 87
Pencil on cartridge paper.
5 minutes each

Simplifying the Subject

Fig. 88 right
Watercolour on Bockingford
200 lb.
52 minutes

The sea front at Sidmouth is almost unchanged since Victorian times. A complicated subject, it needed much thought to decide to what extent I could simplify it and still make a picture.

I spent a few minutes observing the scene, then I started the drawing (fig. 88). I began the painting with the sky and the background. Then I worked on the main group of buildings on the right and to the centre, leaving a lot of white paper to help give the illusion of sunlight. I painted a blue-grey wash over the buildings on the left, to help to keep them in the distance.

When I had finished, I wondered whether the dark wall of the steps leading down to the beach was too dark. But it makes a strong contrast against the sunlit buildings, and the shape is broken by the steps and the foreground boats.

I spent 40 minutes on this painting so I must try again sometime, and simplify it even more.

After unwinding for a little while, I turned my seat round and saw the view in fig. 89. The brightness of the green seaweed on the concrete and metal groyne was staggering. It looked unreal.

I painted the sky and sea first but just before I did so, a yacht came into view and I drew it in. I didn't like only one; it looked wrong. So I drew two more and left white paper for the sails and hulls as I worked down the sky and sea areas. For the green seaweed I used predominantly Hooker's Green No. 1, with a touch of Crimson Alizarin and French Ultramarine. Notice how I left white paper in the foreground sea area to represent small waves breaking.

I was pleased with the painting but I wished I had moved the groyne a little to the right.

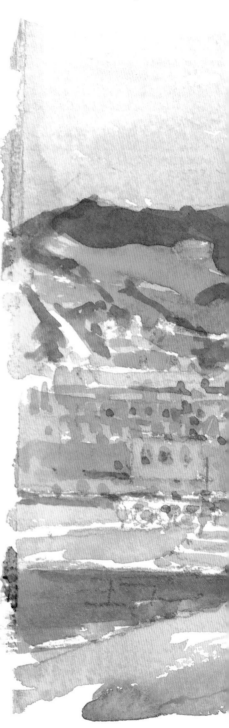

Fig. 88 right
Watercolour on Bockingford
200 lb.
52 minutes

Fig. 89
Watercolour on Bockingford
200 lb.
25 minutes

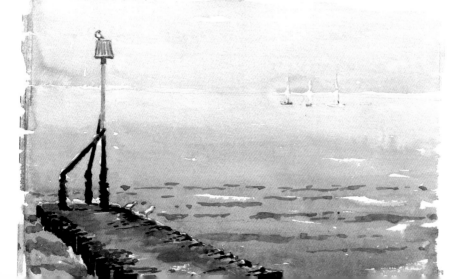

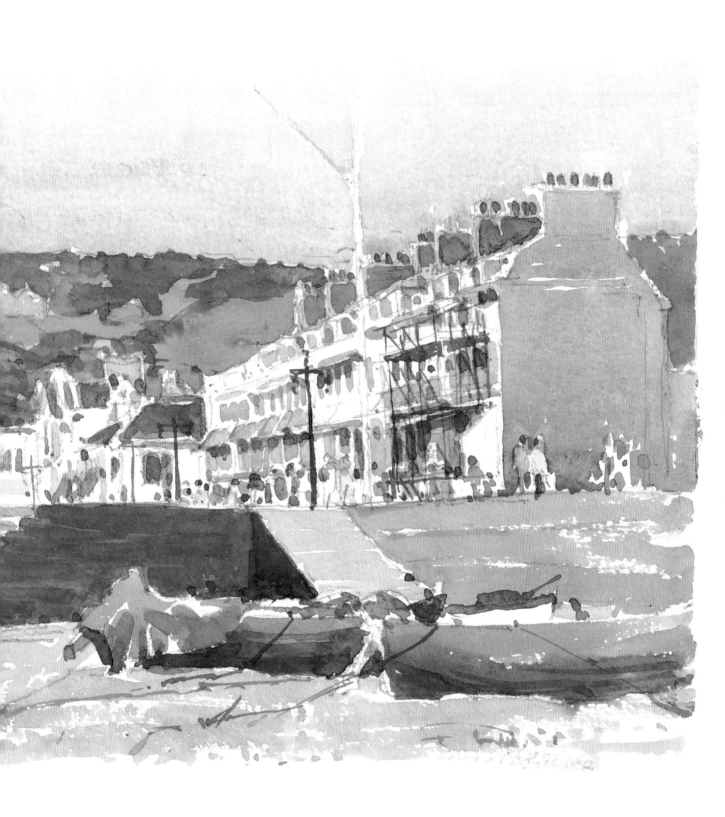

STUDIO WORK

Paintings worked in my studio, using some of the half-hour sketches and paintings as a starting point

Exmouth beach. *Watercolour on Whatman 200 lb Not, 33×46 cm (13×18 in). From a pencil sketch worked on cartridge paper, on the beach*

CAPTURING MOOD

Fig. 1 right
Big Ben. *Oil on hardboard,*
41×51 cm (16×20 in)

While painting Big Ben in watercolour, I had decided that I would use it as my starting point for painting an oil, back home in the studio. The watercolour (fig. 34, page 38) triggered my visual memory of the scene, and I could have worked with only that as my reference. But as the subject was architectural and a well-known place, I also used for reference a photograph which I had taken while doing the watercolour.

I had to fix an atmospheric mood in my mind before I started to work on the painting (fig. 1). I decided on a typically wet, murky London day, where occasionally the sun almost gets through the clouds and casts soft light and indistinct shadows on an otherwise dull and uninteresting scene. I observed this mood hundreds of times during the 20 years I spent working in London.

One feature that has always stuck in my memory is the almost silver brightness of the unruffled water, where the soft sunlight rests. To achieve this effect in the painting, I needed to have some darker tonal work in the water as a contrast against the light areas. When I did my watercolour and took the photograph, the water was dark and uninteresting, and there were no obvious reflections. But I needed them for this painting for contrast; also, to use reflections is the best way to create the illusion of water in a painting.

So I used my imagination and experience, and painted the reflections of the buildings. This gave me the contrast I was looking for and I was very happy with the water, and with the completed painting.

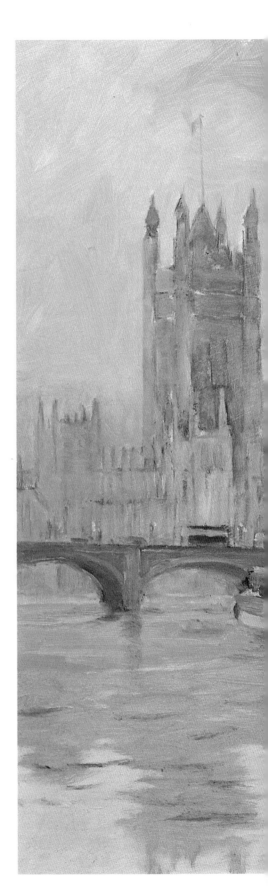

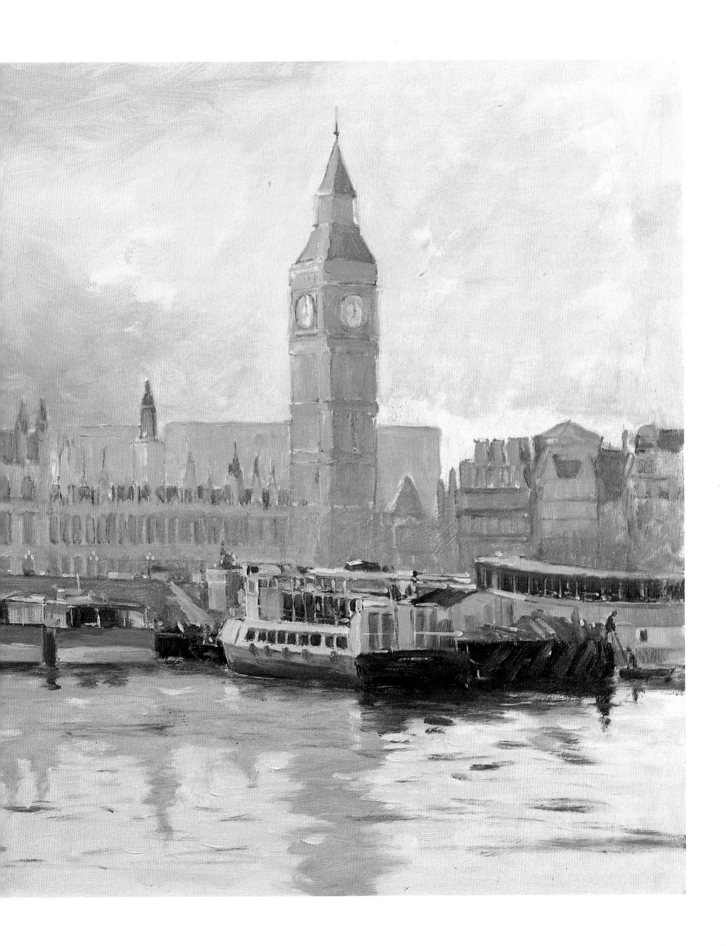

WATERCOLOUR FROM PENCIL SKETCH AND PHOTOGRAPH

SPACE AND LIGHT

Fig. 2
Pencil on cartridge paper

One of the sketches I did when I went to Trigg's Lock can be seen in fig. 2. I also took a photograph from a point further away, featuring another boat (fig. 3). I had been inspired by the very still water, leading up to Send church in the distance.

When I looked at the sketch some weeks later in the studio, I was concerned that, because of their foreshortening and their shape being changed by the covers, the two boats might not read very well in a large watercolour painting. I decided to compromise and use the photo of the third boat because this was a good shape and would therefore take away any doubt that the other two covered objects were boats. It also provided a point of interest (fig. 4).

Notice how I left out the trees on the river bank which cover most of the church, and I left white the dark fence posts above and to the right of the furthest boat. I felt

that to paint them dark would divide the top right of the picture and stop the eye from going naturally up to the church.

Just one wash was put on the water first and when it was dry the reflections from the boats were painted. To help the water in the foreground to appear flat, I painted in some water-lily leaves. It wasn't until I had finished the painting that I realized spring was a little early for water-lilies but, looking at the painting, it could be early summer: there is nothing definite in it to suggest either season.

When I had painted the water, I kept this area covered with paper while I worked on the rest of the painting. I didn't want to splash or mark it or the effect would have been ruined.

I made the painting portrait shape, which I felt helped the composition.

Fig. 3

Fig. 4 opposite
Send church from Trigg's Lock.
Watercolour on Whatman
200 lb Rough, 56×38 cm
(22×15 in)

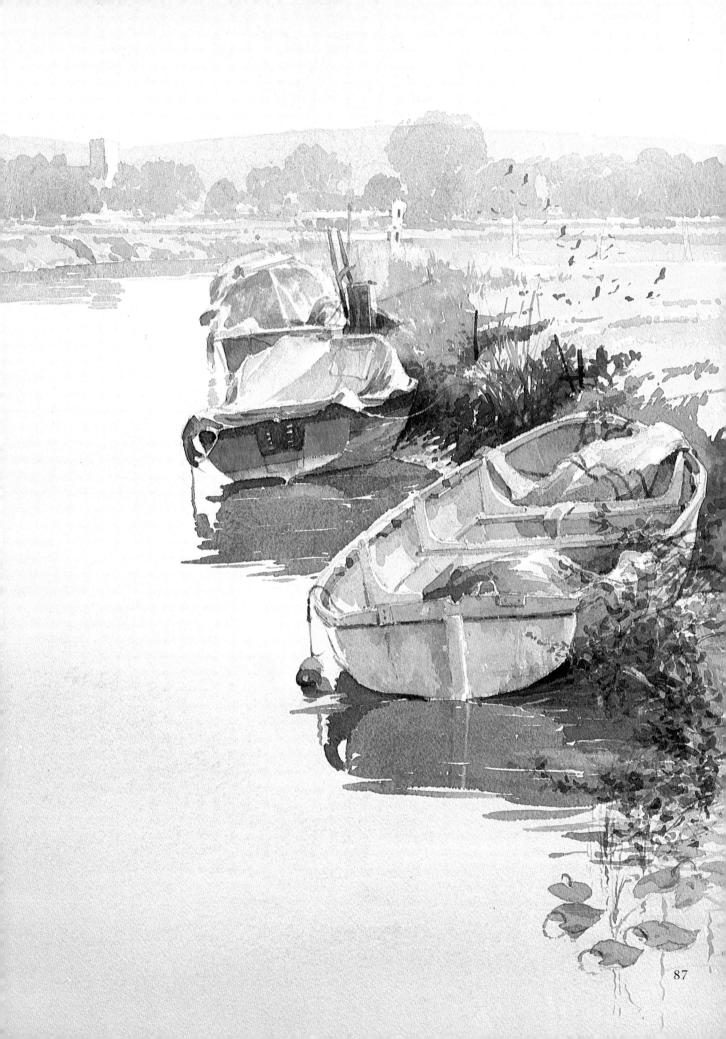

REFLECTIONS

Fig. 5

Fig. 6 opposite
Trigg's Lock, reflections.
*Watercolour on Whatman
200 lb Rough, 56×38 cm
(22×15 in)*

Fig. 7
Detail from fig. 6 opposite

When I saw the scene in this photograph
(fig. 5), I wanted to paint it there and then.
But I had forgotten to take my chair and I
couldn't sit in the wet mud on the bank, so
I took a photograph and decided to paint
from it in the studio at home (fig. 6). The
whole inspiration came from the reflections.
I stood and looked, carefully observing
them and deciding how I would paint them.

Back in the studio, I left the reflections
until I had painted everything except the
tree on the left. I had decided that they had
to be done with one wash only, first time. If
this went wrong, then the painting would
be ruined.

Professional or not, it is at these times
that you feel a prickle at the back of your
neck, and the thought that you could lose
confidence is frightening. You need this
above all else, as the brush strokes must be
worked with looseness, reasonable
accuracy and speed.

I mixed four pools of definite colour,
making sure I had more than enough. You
can't run out in the middle of a passage like
this! I then went through the motions (dry
run) of painting, until I felt I knew the
reflections and could almost see them on
my paper. A couple more dry runs, a glance
to the heavens, and the first brush stroke
went on. I worked from the top to the
bottom, changing the colour as I worked.
There was no stopping until the last blob of
the chimney reflection was put at the
bottom of the painting.

It worked, and I was very pleased with it
(and myself), except for the reflection of the
lock gates. I felt this could be a little darker.
I must have been feeling confident, because
I put another wash over the gates and I
could easily have ruined the whole
reflection if this had gone wrong.

Notice how my painting has changed
subtly in places from the photograph. This
was because I was making a painting – not
copying a photograph.

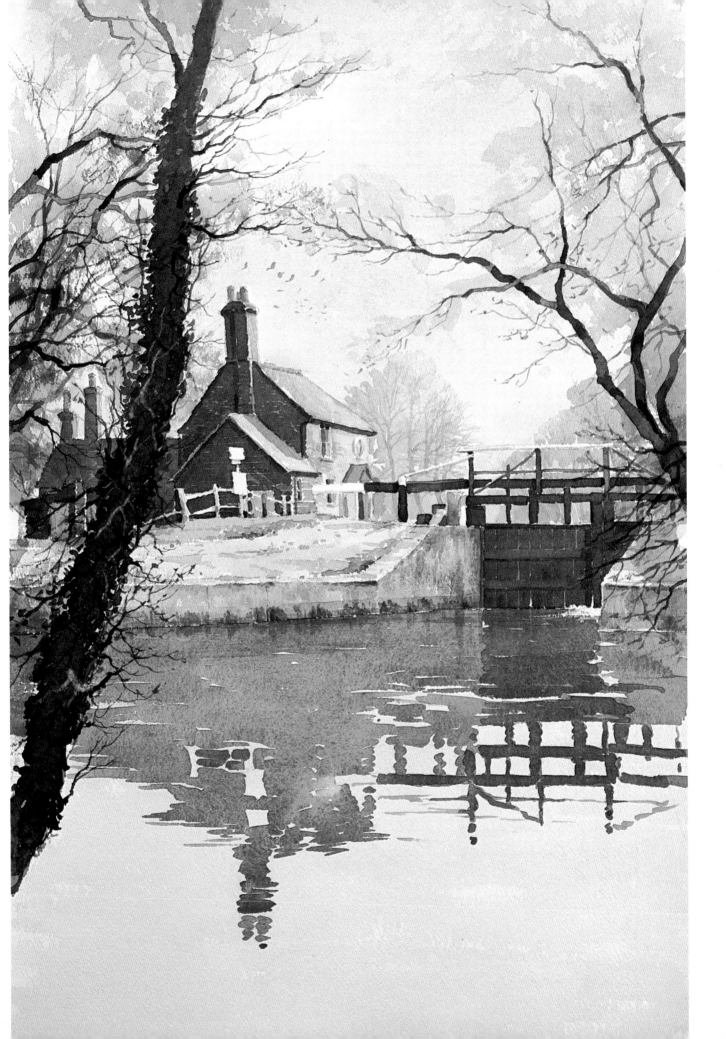

SEASONAL LANDSCAPES

One of the joys of working from a sketch done outside is that you can use your own interpretation of the time, weather or season.

I used a pencil sketch (fig. 8) which I did on an early walk (page 17) for the first picture, a snow scene. I really like painting snow in watercolour; to me it is a natural watercolour subject.

I moved the middle tree over a little to the right, to allow room to put a man coming up the lane with his dog (fig. 9). I left the middle distance fields as white paper until nearly the end of the painting, but I decided they were fighting with the brightness of the foreground snow (white paper) and so I put a light wash over them. This worked well and has kept the brightest, sunlit snow in the foreground.

For most of the small branches on the trees and in the hedgerows I used a nylon rigger brush (a Dalon Series D.99 No. 2), remembering, of course, always to let the brush go in the direction that the branches grow. I find this brush works wonders.

When you copy from a sketch, don't try to copy every line, or you will find you become very tense, and your painting won't have the natural freedom of your sketch. Use the sketch to work from, not to make a copy.

Fig. 8
Pencil on cartridge paper

90

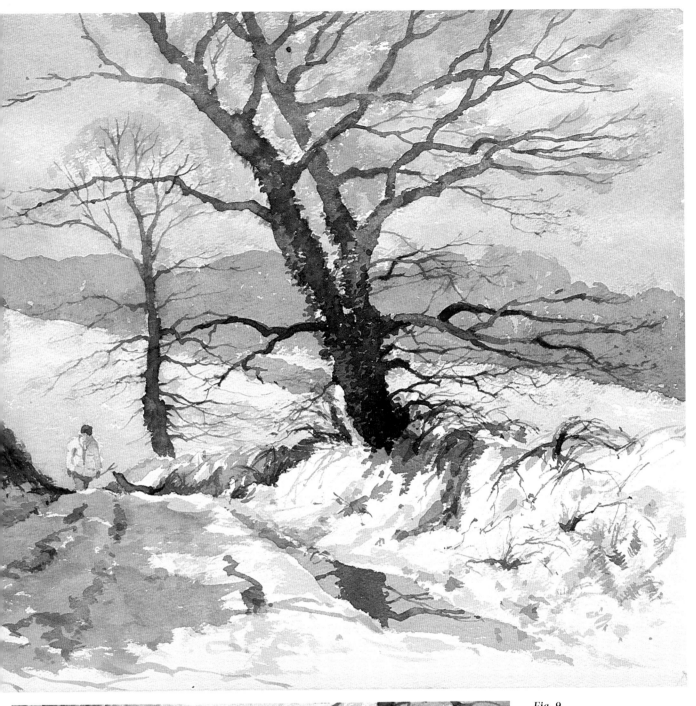

Fig. 9
Snow scene. *Watercolour on Whatman 200 lb Rough, 38×56 cm (15×22 in)*

Fig. 10
Detail from fig. 9 above

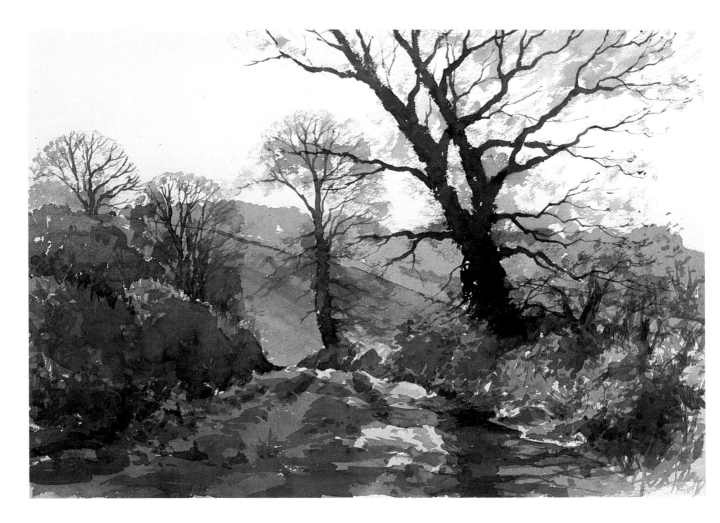

THREE WATER-COLOURS FROM ONE PENCIL SKETCH

Fig. 11 above
Evening, late autumn.
Watercolour on Whatman 200 lb Rough, 38×56 cm (15×22 in)

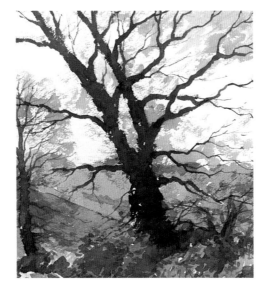

Fig. 12
Detail from fig. 11 above

92

The second painting, which I did the same size and on the same paper, I decided to paint in the mood of an early evening in late autumn (fig. 11): the sun has been out all day but it is now going down, the colours of the landscape are warm, and there is a dampness to be felt in the air. If I am sketching with pencil at this time, I find the pencil will not 'grip' the paper, which gets slightly damp so that you can't draw dark or clear lines – most annoying!

I started by painting a pale yellow wash over the whole of the paper. This helped to give the picture an overall warm glow. I didn't put any detail in the foreground tree; I simply let it account for itself as a strong dark silhouette. When you rely on a silhouette, you must make sure that the shape is good because you have no tone to tell the story.

I was quite free and loose with this painting. I like the colour, the tonal values and the freedom of brush stroke that the picture shows.

The following day I gave myself a real challenge: to paint from the sketch, the same size as the other two – in half an hour (fig. 13). Drawing was not to be included in

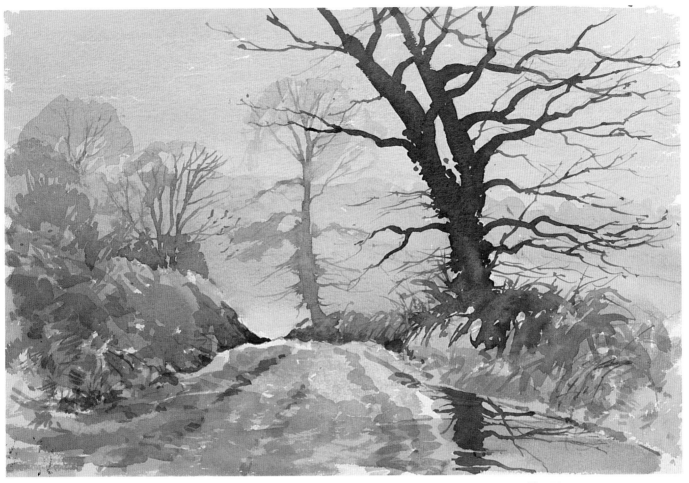

Fig. 13
The large half-hour one.
*Watercolour on Whatman
200 lb Rough, 38×56 cm
(15×22 in)*

the half-hour, and to dry the paint quickly I had one aid that you don't get in the field – a hair drier. Yes, you can use a hair drier in the studio for a half-hour painting – I made up the rules!

I decided to paint in the mood of the afternoon when I had done the sketch. I felt the tree was just a little too dark, but acceptable, and the reflection in the puddle on the right could have been simplified slightly – it looks like a giant spider! But the painting holds together very well, which is more than I did when I finally put down the brush 33 minutes later. I felt absolutely exhausted. There is a lot of paper to cover in half an hour and it's amazing how fast the hand has to work.

Perhaps you would like to try one this size. If you think it is not too complicated for you, copy my sketch.

I do like the way nature creates good compositions for us to copy. This scene in particular has a very good traditional landscape composition. It is by sketching from nature that we gain experience to enable us to work indoors and create our own little area of countryside.

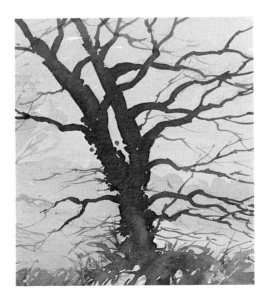

Fig. 14
Detail from fig. 13 above

93

HARBOUR SCENES

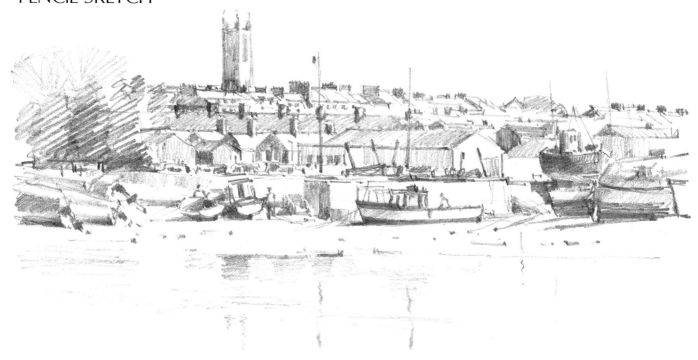

Fig. 15
Pencil on cartridge paper

This pencil sketch (fig. 15) I did at Exmouth harbour and I decided to use it to make three oil paintings in the studio. Because of the complicated background of houses and general harbour bric-à-brac, I also used as reference a photograph I had taken at the time of doing the sketch (fig. 16).

When I am making a pencil sketch of a scene like this, I always take a photograph if I have my camera with me. I could not carry all the colour and detail information in my head for such a complicated subject. I have painted Exmouth harbour many times and know it quite well, and I am sure I could paint from a pencil sketch only – with luck on my side. But for a new scene, as busy and complicated as Exmouth, I should

need more than a black and white pencil sketch to enable me to work at home.

The mood I chose for the first painting (fig. 17) was a sunny day, like the one on which I drew the sketch. The chimney-stacks on the houses in the middle distance at Exmouth always worry me. The reddish-yellow brick looks very bright and strong in sunlight and I tend to paint it too red. I believe that this time I have kept the chimney-stacks firmly on the house roofs. Notice how the white fishing boat to the right of centre is the only one with any suggestion of detail. This allows the eye to rest on it and not wander around the picture.

I feel I captured the mood of the day and I was pleased with the painting.

Fig. 16

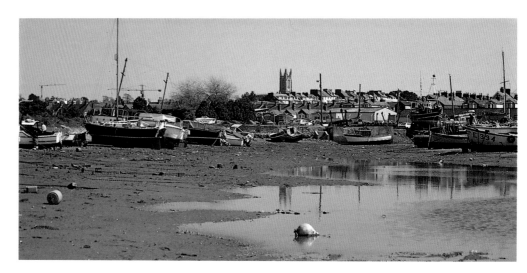

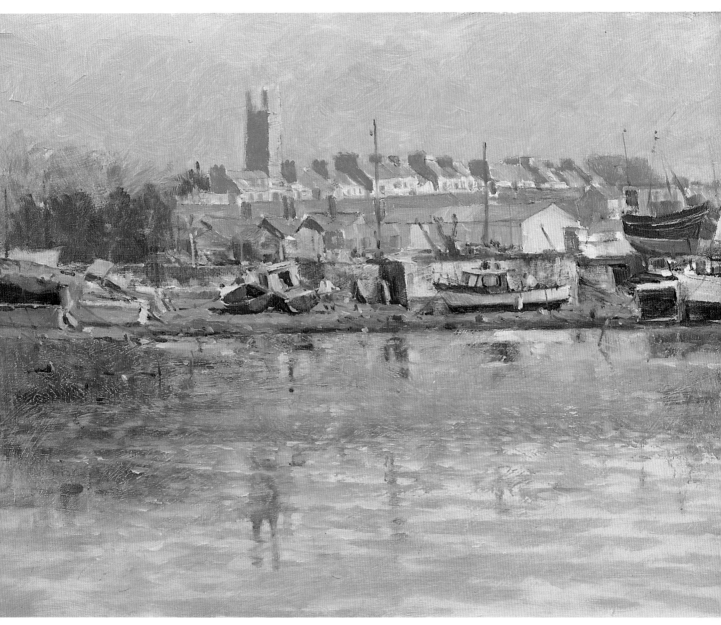

Fig. 17
Sunny day, Exmouth harbour.
Oil on hardboard, 30×41 cm
(12×16 in)

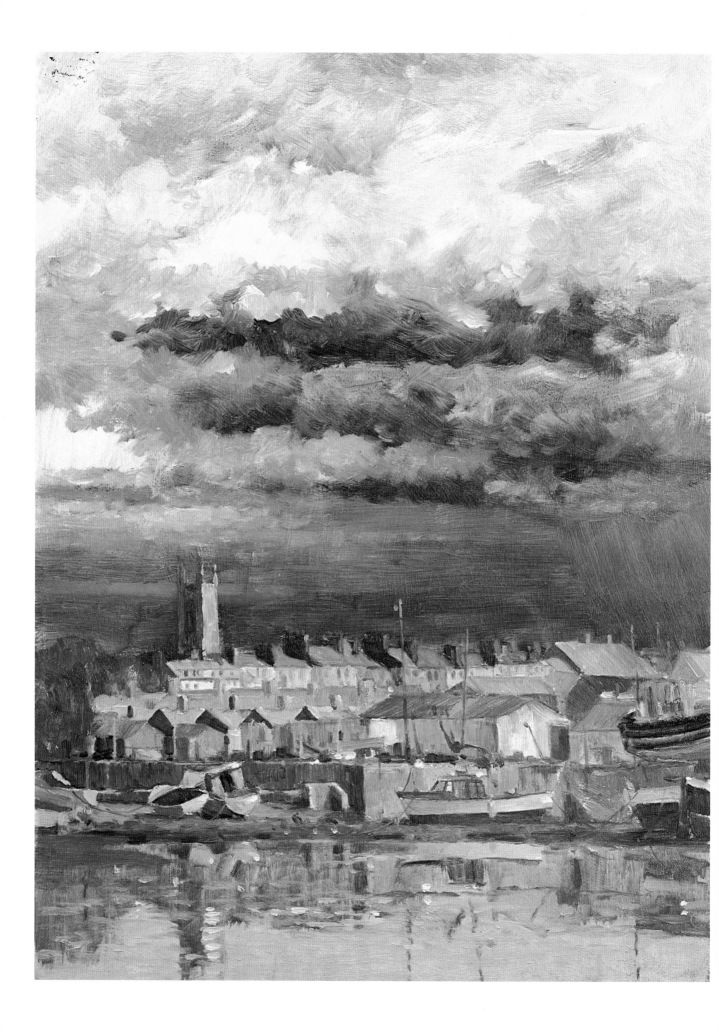

A dramatically different painting can be seen in fig. 18. I was sitting in the studio trying to see a 'mood' in my mind's eye. I remembered some of the days when I have been painting at the harbour: the sky has turned as black as coal and an eerie light has covered the whole scene. I am sure you have experienced this mood of nature at some time. I know my students have, and got wet, at Exmouth!

Because the drama came from the sky, I painted the picture portrait shape to allow me to paint more sky than landscape. All the colours I have kept in the cool, blue range, except for a touch of pale orange on the left of the quayside and some dark red on the right-hand boats.

I haven't suggested the figures in the boats in this picture. Without them the painting gains a more eerie atmosphere. I imagined the rain coming over the Exe estuary from the right. I have suggested this by showing rain falling from the clouds at the bottom right of the sky. In a few minutes there will be a downpour.

The third painting (fig. 19) is again completely different in mood. It is difficult to paint the last light of the day on the spot, simply because there isn't much time and you cannot see your work well enough in the failing light.

In the studio I worked on prepared hardboard and gave it a thin wash of Yellow Ochre before I started. The colours are all warm blues and greys, as usual mixed from my three main colours: Cobalt Blue, Crimson Alizarin and Yellow Ochre, plus Titanium White.

I have given a little more prominence to the white fishing boat, so that it can just be made out on the mud. Have you noticed that I haven't put a light side to the church tower? It is one tone, painted in a simple silhouette, which is echoed in the reflection.

I was very happy with this painting, and I like it the best of the three.

THREE OILS FROM ONE PENCIL SKETCH

Fig. 18 opposite
Storm over Exmouth. *Oil on hardboard, 41×30 cm (16×12 in)*

Fig. 19
Dusk at Exmouth. *Oil on hardboard, 30×41 cm (12×16 in)*

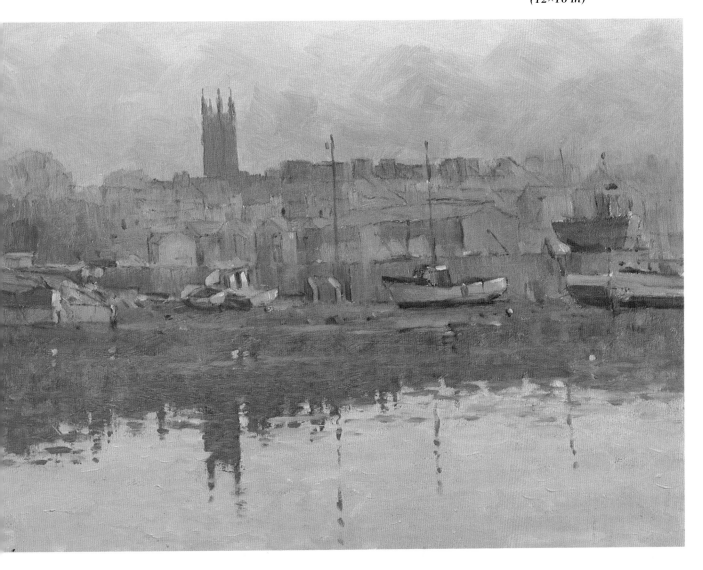

TREES IN LANDSCAPE

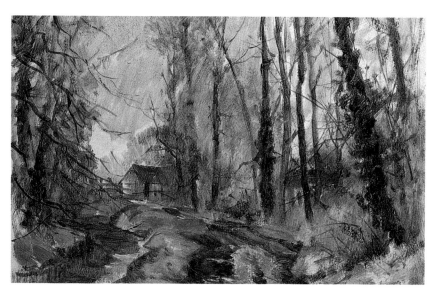

Fig. 20
Oil on Whatman 200 lb Not

Fig. 21 opposite
Watery sunlight, Cadhay.
Watercolour on Whatman
200 lb Rough, 51×38 cm
(20×15 in)

It is not often that I use an oil painting as a starting point for a watercolour; it's usually the other way round. But I felt I had enough information in the oil painting I did near Ottery St Mary (fig. 20). In addition, I was inspired by the oil, which I like; I believe it has tremendous feeling and atmosphere.

But I wanted to paint it differently in some way. I decided to paint it portrait shape and much larger (fig. 21). In the oil painting you can see only a suggestion of the house which appears to the left of the white building in the watercolour. I decided it needed it. Remember, when painting a watercolour from an oil you have to decide carefully what to leave out and what new areas or features you have to create. I slightly adjusted my viewpoint. This brought in the house more, and I also eliminated some of the trees on the right.

I made quite a careful drawing of the group of trees to the right of the white house. They were painted in one wash and left. Note how I didn't paint over the two light tree trunks in front of these trees.

The trees opposite these, on the left, were drawn and painted carefully. I felt this was important because they are in the area of the picture where the eye rests. The foreground trees were painted very dark to contrast with the sunlit area. This emphasized the brightness, and the lightest parts of the painting. The water and the white building I left as white paper.

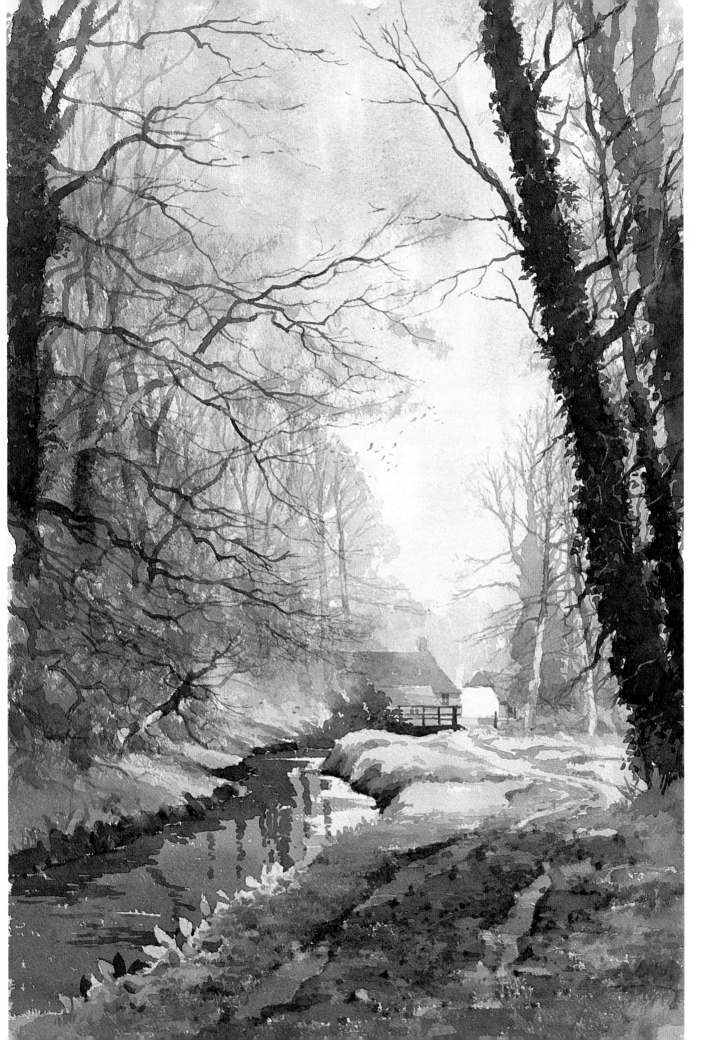

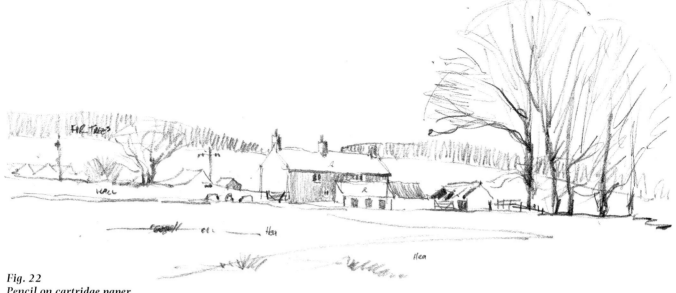

Fig. 22
Pencil on cartridge paper

WATERCOLOUR FROM PENCIL SKETCH

MOORLAND LANDSCAPE

A pencil sketch (fig. 22) was my starting point for the painting in fig. 24. This is a typical watercolour from a pencil sketch, where nothing has been changed or moved to alter the composition. Looking at the watercolour, I would have liked more movement, more drama in the painting but, on reflection, it has the feeling and the presence of the Yorkshire Moors. Everything looks open and flat. The sky is heavy with April showers being dropped occasionally as the clouds move fast and ever-changing across the Moors.

The painting may look rather bleak and desolate, but I was trying to portray just that. Note that the whites of the sky, buildings and foreground are all areas of unpainted paper.

100

Fig. 23
Detail from fig. 24 below

Fig. 24
April showers. *Watercolour on Whatman 200 lb Not, 38× 52 cm (15×20 in)*

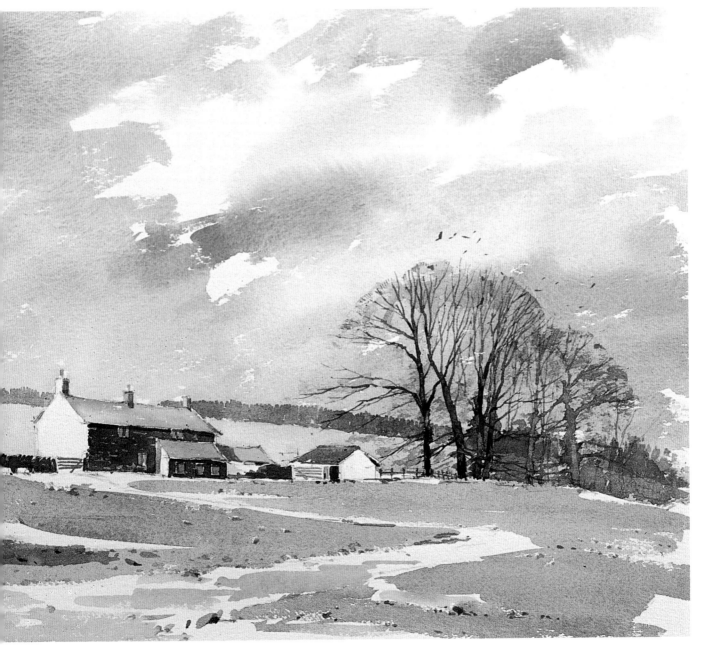

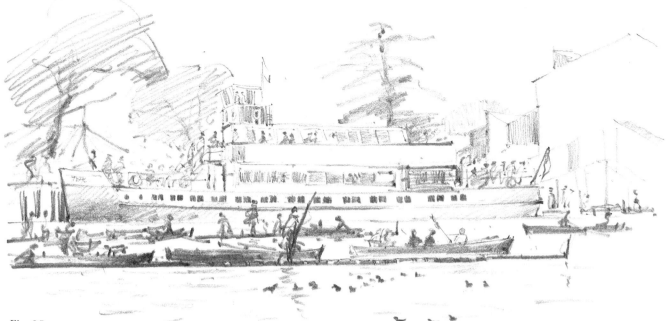

Fig. 25
Pencil on cartridge paper

WATERCOLOUR FROM PENCIL SKETCH

CREATING ATMOSPHERE

I drew the pencil sketch in fig. 25 while sitting on a landing-stage, watching the activity on the water. The large pleasure boat had just berthed and was unloading and taking on new passengers for a trip on the lake.

Quickly I started to sketch because I knew the boat would be there for only a short time. Ten minutes into the sketch, I realized that the boat's departure wasn't going to be the problem, but the weather was. A heavy, black and ominous cloud was moving very fast over our part of the lake. The effect of the light was quite unreal. At one point, half the scene was in darkness and the other half in bright white light, silhouetting the boats and their crews, and also the dozens of ducks, squabbling over the remains of picnics thrown from the incoming rowing boats. I just managed to draw the scene and reach shelter as the heavens opened and the torrential rain came and went, in a few minutes.

I didn't attempt to shade in the tonal values for the atmosphere in the sketch – there wasn't time and I should have lost

some of the drawing, so I had to remember the effect and create it in the painting.

I painted the picture as normal, without the dark sky. When this was dry I worked over the left side with a series of dark washes until I felt I had achieved the right atmospheric effect (fig. 27). The water on the right was left as white paper, which helped to create the eerie bright light moving over the water. I worked the picture with cool blue-greys to help create the calm atmosphere before a storm. I bought a postcard of the boat so that I had a reference for the number of windows, etc. If the boat had been just a suggestion in the background, I shouldn't have worried, but it is prominent, and the painting shows a real place and a well-known boat, so within reason it had to be correct.

Fig. 26
Detail from fig. 27 below

Fig. 27
Sunlight on Lake Windermere.
Watercolour on Whatman
200 lb Not, 38×51 cm
(15×20 in)

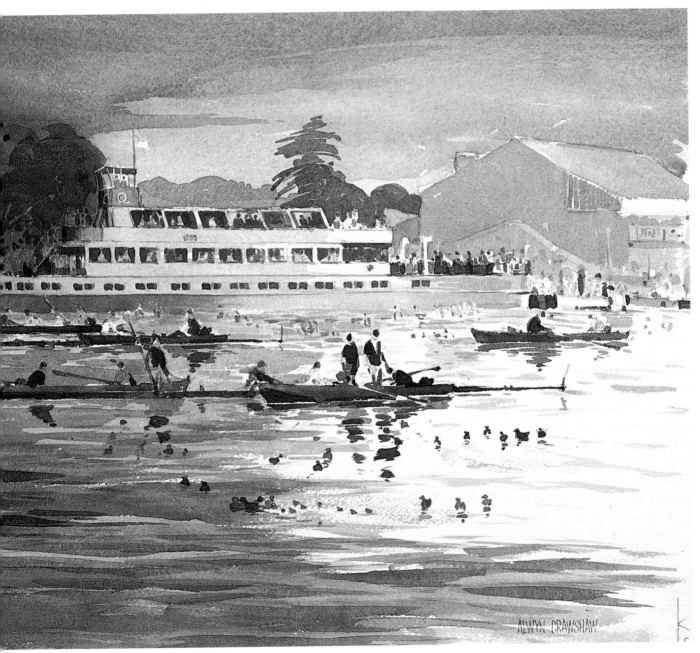

OIL FROM PENCIL SKETCH

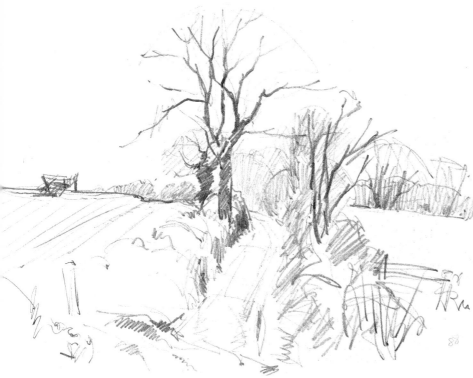

EARTH COLOURS

Fig. 28
Pencil on cartridge paper

I drew the picture in fig. 28 on a sketching trip near my studio, during the 'tractor confrontation' period, when we had experienced lots of rain.

There is no particular reason why I liked the view, but it really inspired me. I think it was all the mud that had been churned up at the bottom of the hill as the tractor had gone into the field on the left. It must have been almost knee deep in places; I have never before seen it like that. In one light it was just red-brown mud, but in another light it reflected the sky and became alive with a smooth surface like blueish whipped cream. This is how I decided to paint it (fig. 29).

I used prepared hardboard and worked thinly, as usual. It was only a few days after I had drawn the sketch, so I had the colours and the mud firmly in my visual memory. I was concerned that the mud path that broke away from the main path leading into the picture would prove a distraction and give two 'roads' for the eye to follow. But I think that, because of the two distinctly shaped trees and their dark colour, the eye goes up the path and doesn't get led off at the beginning.

Fig. 29
Oil on hardboard, 25×30 cm
(10×12 in)

USING HOLIDAY PHOTOGRAPHS

Fig. 30

After missing my painting chances in Paris because of the Tour de France cycle race, I decided to paint a picture from a photograph taken on our first day in Paris, when we arrived after a heavy rain shower. The print was dark (fig. 30), but I could manage, and to help me I had a colour slide.

I gave myself a half-hour challenge in the studio, pretending I was still in Paris painting the scene.

So, prepared with my sketchbook, I began my half-hour painting (fig. 31). I imagined that the dark rain clouds moved into the distance to reveal blue sky and feathery white clouds, with the ground still wet, reflecting its immediate surroundings. I painted the sky first, leaving white paper for the clouds, then adding darker colours down to the horizon.

I left the distant buildings white and pale yellow as if the sun had just hit them, but the rows of trees behind and in front of the Eiffel Tower were dark and in shadow. I also imagined the Tower in shadow, as this made it a perfect silhouette against the sky. The figures were kept very simple; there was no time to do anything else with them, but I did paint their reflections.

I enjoyed doing this very much, and for the 27 minutes it took me to complete the painting, I felt I was back there. Just notice how static the photograph is when compared with the life, light and atmosphere in the painting.

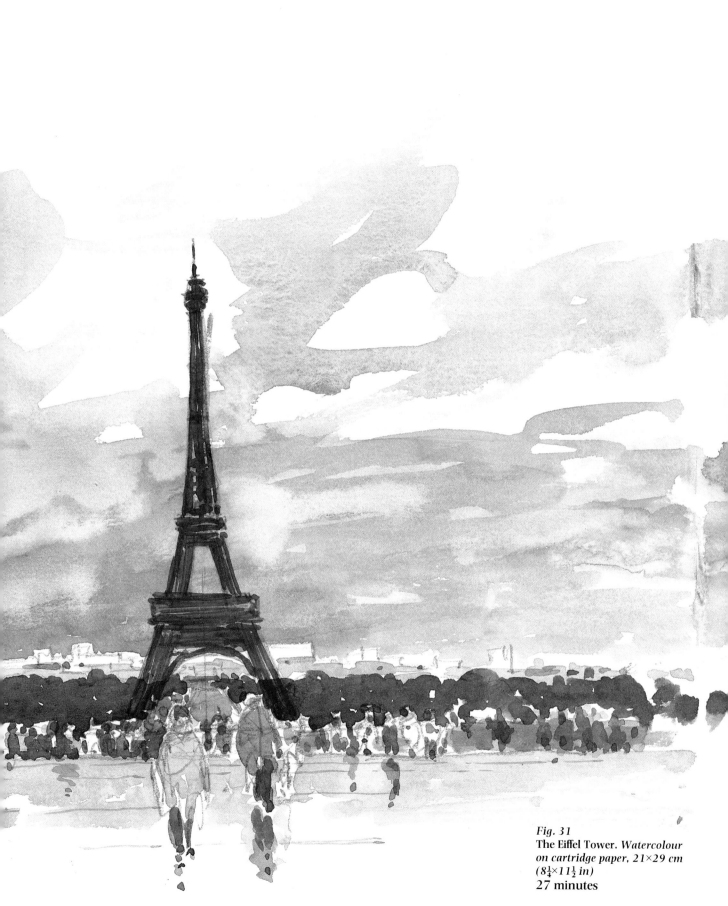

Fig. 31
The Eiffel Tower. *Watercolour on cartridge paper, 21×29 cm (8$\frac{1}{4}$×11$\frac{1}{2}$ in)*
27 minutes

EARLY MORNING MIST

In the summer I went out on one of my local walks and started the oil painting in fig. 32.

The corn had been cut and was now ready to make into straw bales. It was very hot and there was no one about; I had a perfect subject and a perfect day. So I started, and the minute my first brush stroke was painted, the quiet country peace was shattered by the noise of a tractor starting up. It was baling the straw: the race was on!

I suppose it was because I was using oil paint that it took me 15 minutes longer than the half-hour, and as I put on the last brush stroke, the last bale was made. I shall never cease to be amazed that you can come upon a scene in the countryside, or a harbour area, with apparently no life or activity until you start to paint, and then the place comes alive.

Later, in the studio I used this painting for an acrylic picture (fig. 33). Having painted the oil on a hot sunny day, I painted the acrylic as an early morning scene when a mist was just clearing – one of my favourite moods of nature. I also extended the picture to the right and added the rooks. After I had finished the rest of the picture, I put in the mist, using a dry-brush technique, and working the brush over the landscape in the middle distance. I do like the sunlight just catching the tops of the cows, and the warm sunlight playing on the left of the foreground trees. The light on the trees was also achieved by dry-brush technique.

I am not sure which painting I prefer; I like each one for what it has achieved.

Fig. 32 above
Cornfield. *Oil on hardboard, 25×30 cm (10×12 in)*
45 minutes

Fig. 33 left
Cornfield in mist. *Acrylic on canvas, 41×61 cm (16×24 in)*

109

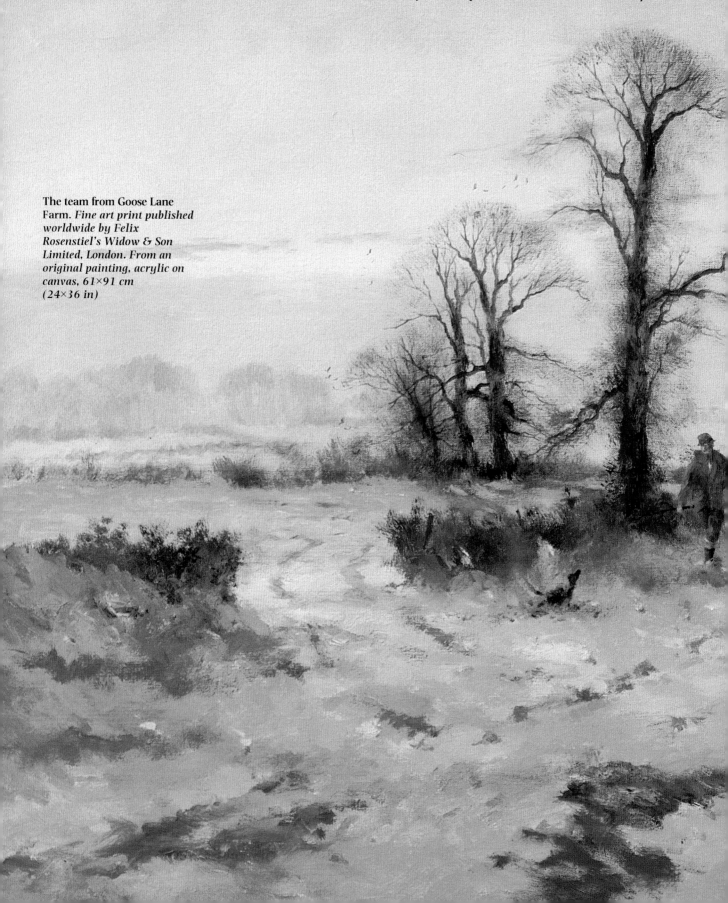

PART THREE

GALLERY

A small selection of my work, painted over the last few years

The team from Goose Lane Farm. *Fine art print published worldwide by Felix Rosenstiel's Widow & Son Limited, London. From an original painting, acrylic on canvas, 61×91 cm (24×36 in)*

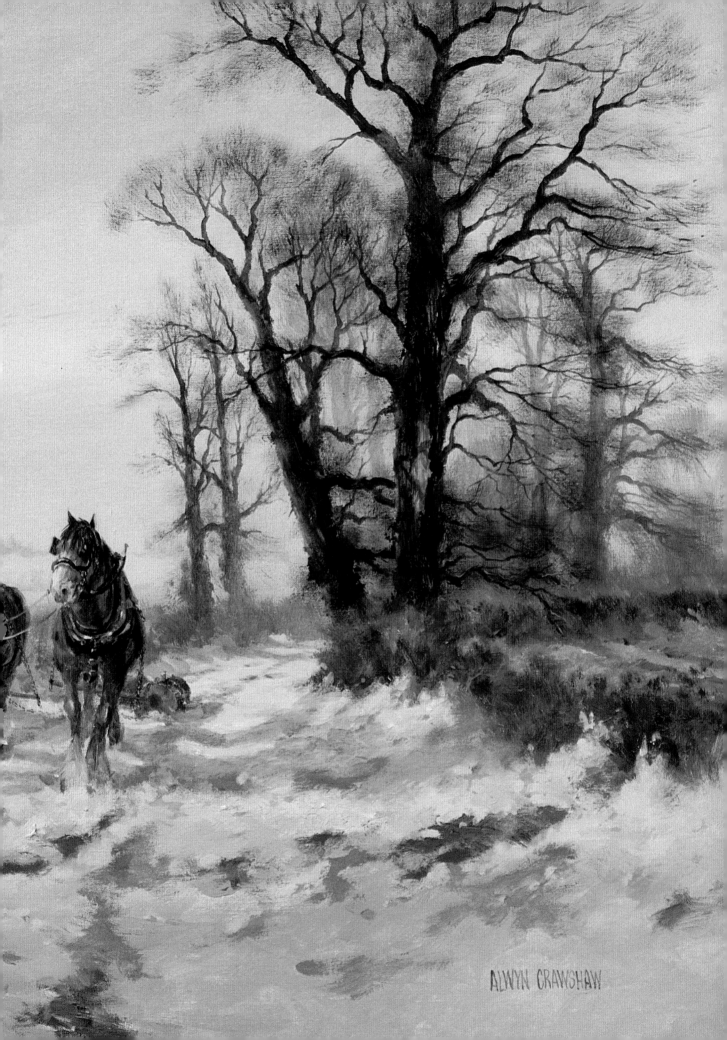

ALWYN CRAWSHAW

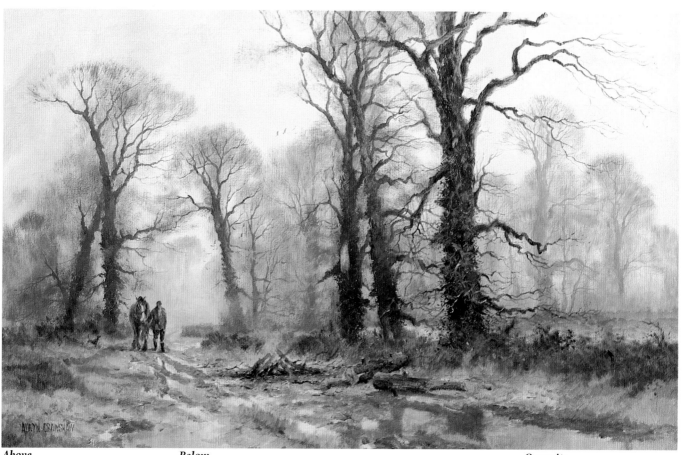

Above
Come on lad – nearly finished.
*Acrylic on canvas, 51×76 cm
(20×30 in)*

Below
Spring. *Acrylic on canvas,
51×76 cm (20×30 in)*

Opposite
Detail from the painting above

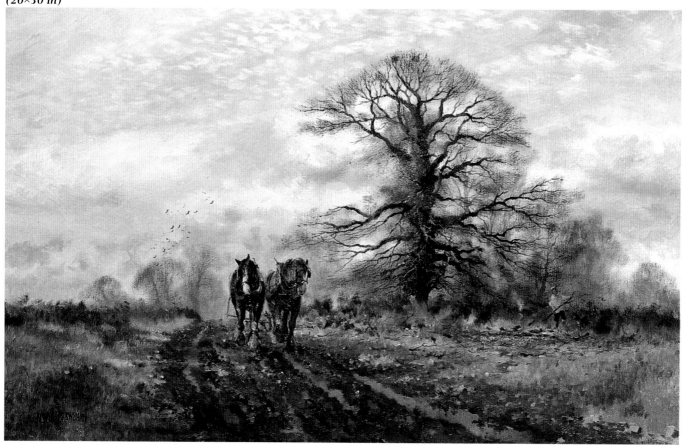

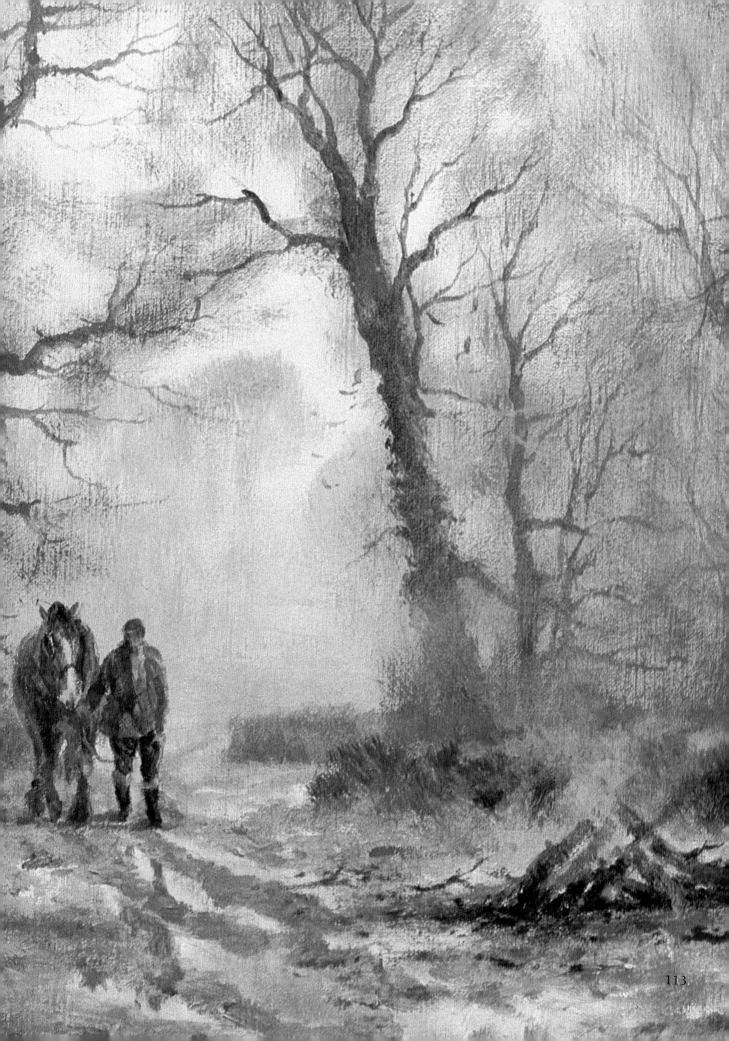

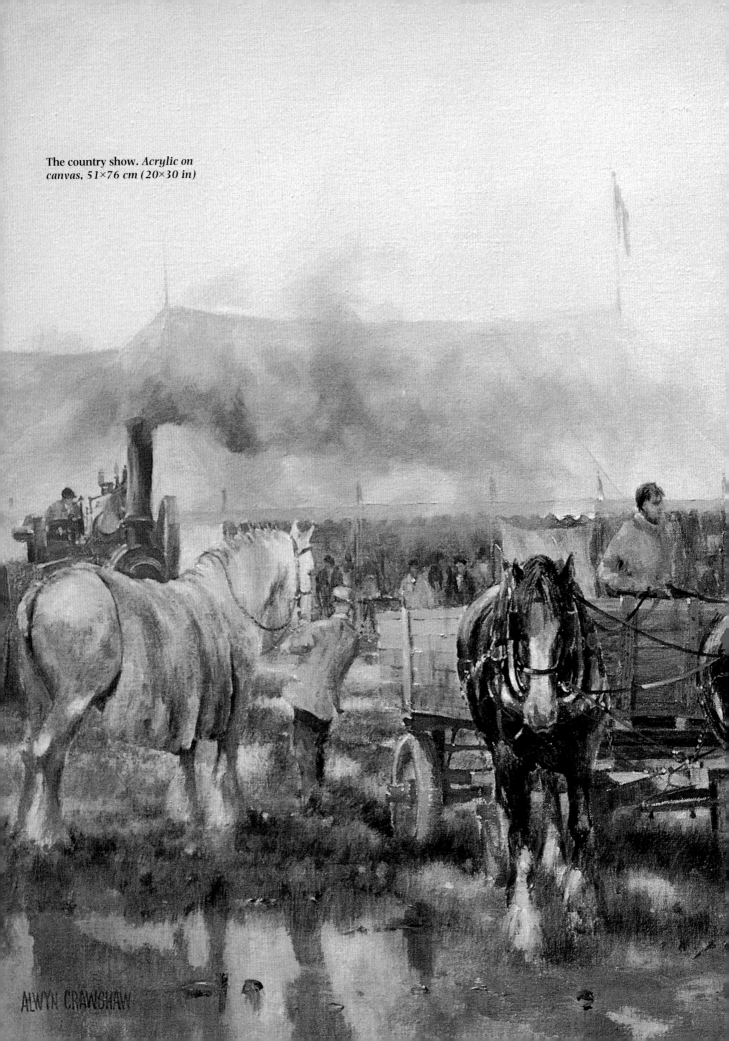

The country show. *Acrylic on canvas, 51×76 cm (20×30 in)*

ALWYN CRAWSHAW

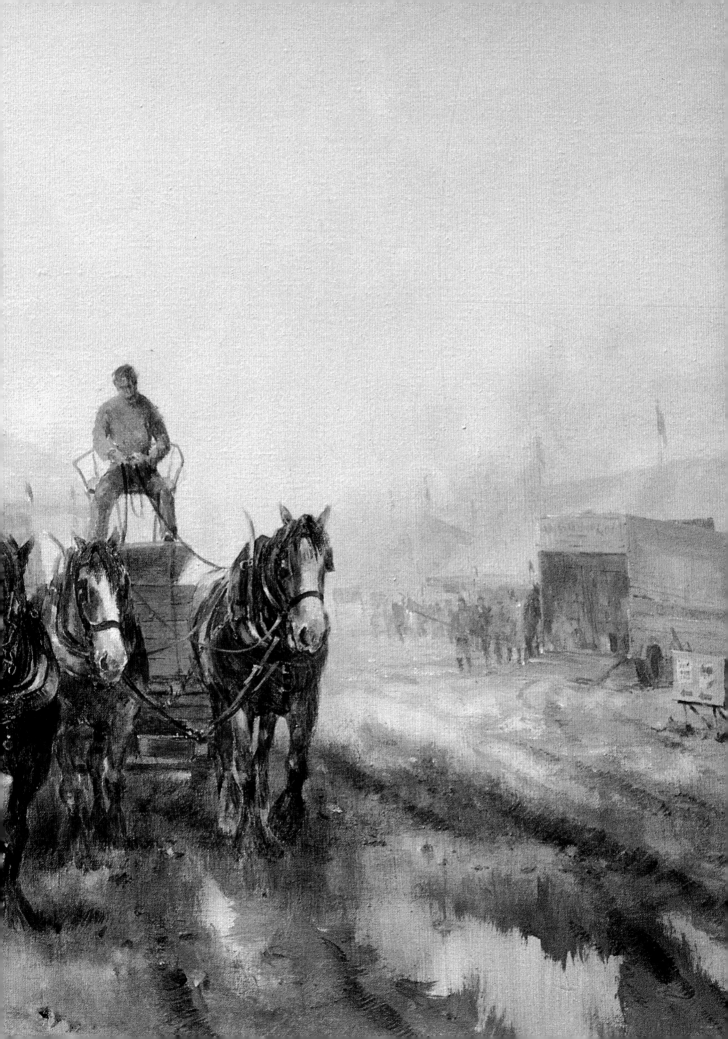

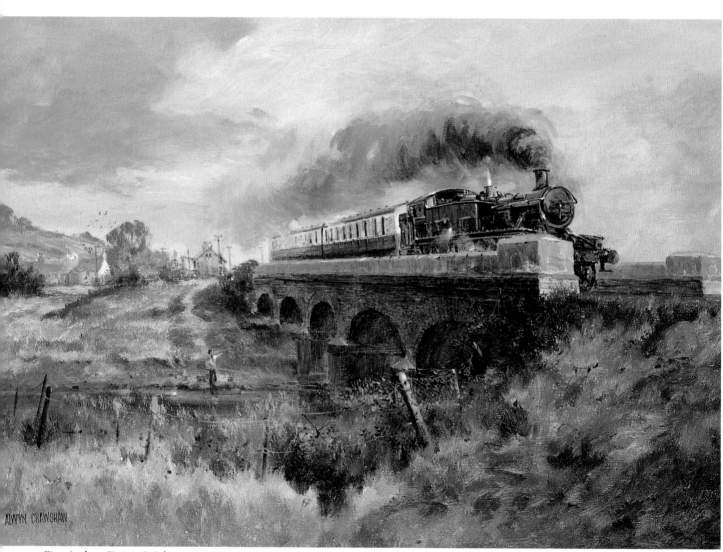

Five Arches, Tipton St John.
Acrylic on canvas, 41×61 cm
(16×24 in)

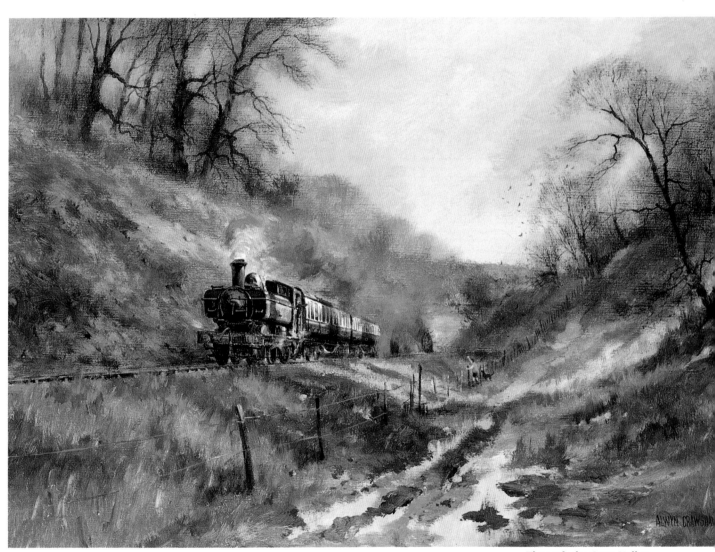

**Through the Otter Valley,
Devon.** *Acrylic on canvas,
41×61 cm (16×24 in)*

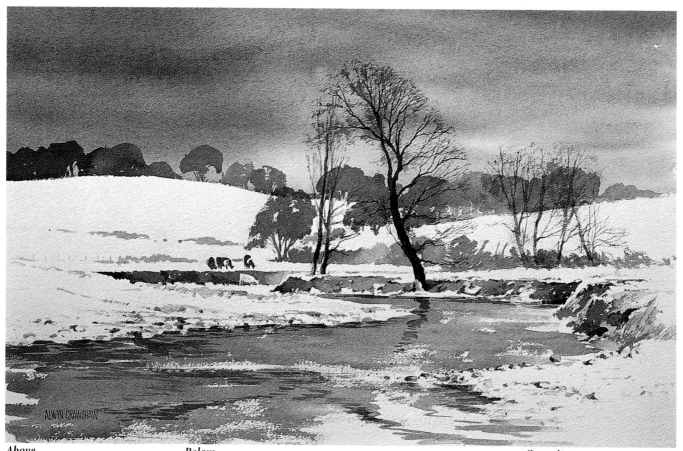

Above
The next morning, snow.
Watercolour on Whatman 200 lb Not, 38×51 cm (15×20 in)

Below
Walk in the snow.
Watercolour on Whatman 200 lb Not, 38×51 cm (15×20 in)

Opposite
The gate. *Watercolour on Bockingford 200 lb, 23×16 cm (9½×6½ in)*

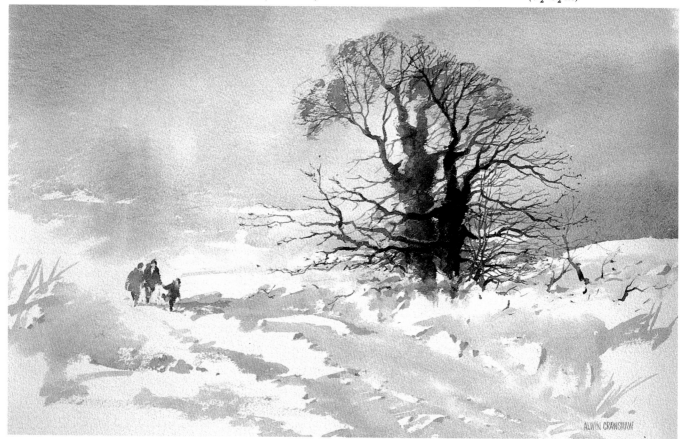

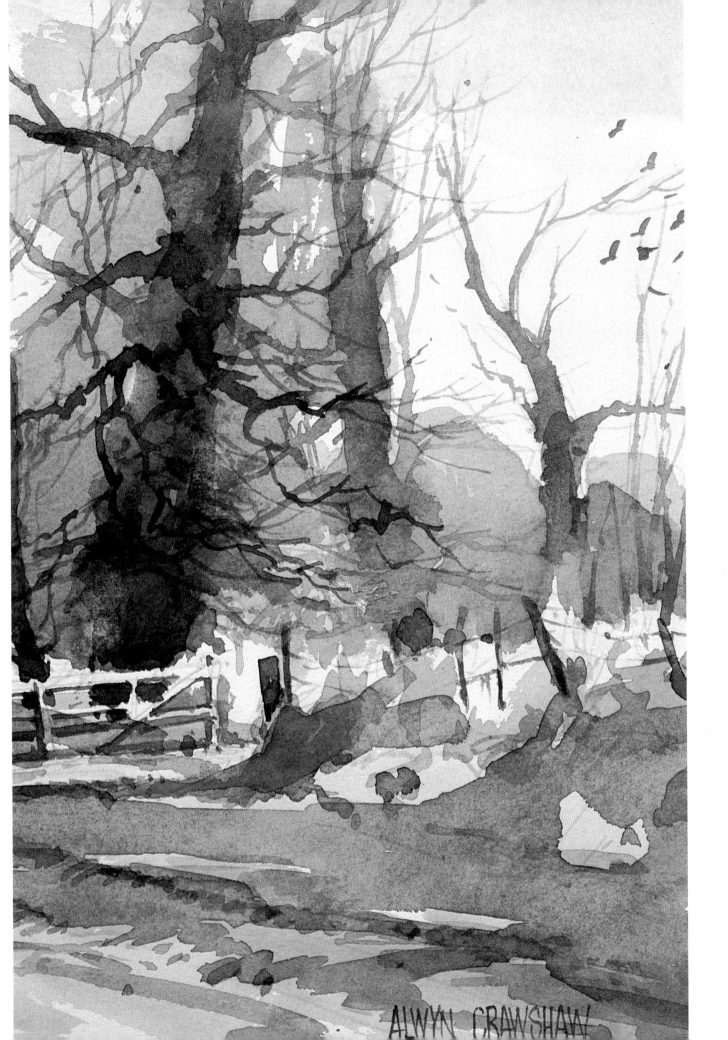

ALWYN CRAWSHAW

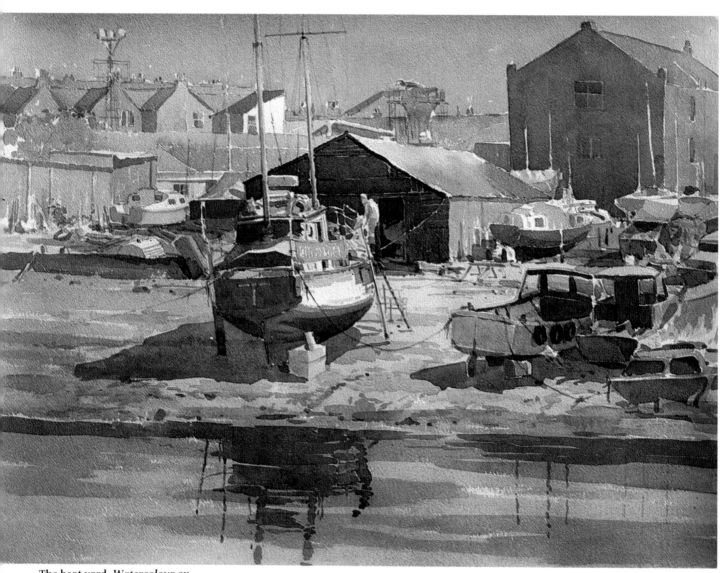

The boat yard. *Watercolour on Whatman 200 lb Rough, 51×76 cm (20×30 in)*

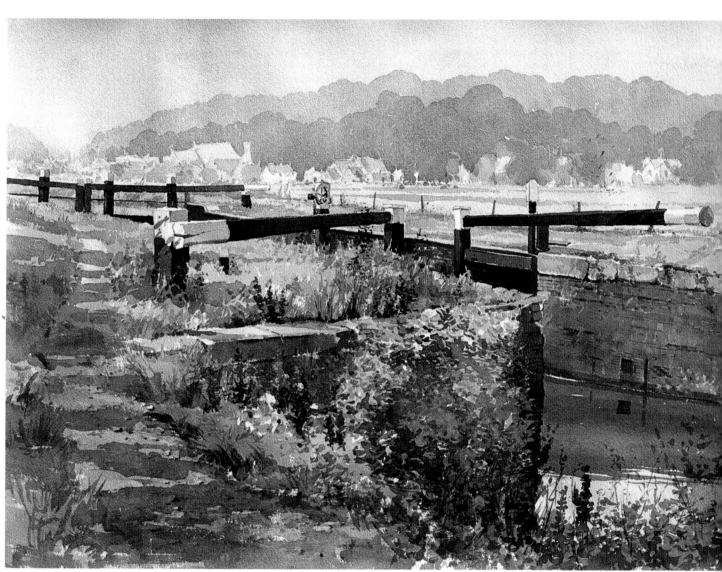

The lock. *Watercolour on Whatman 200 lb Rough, 51×76 cm (20×30 in)*

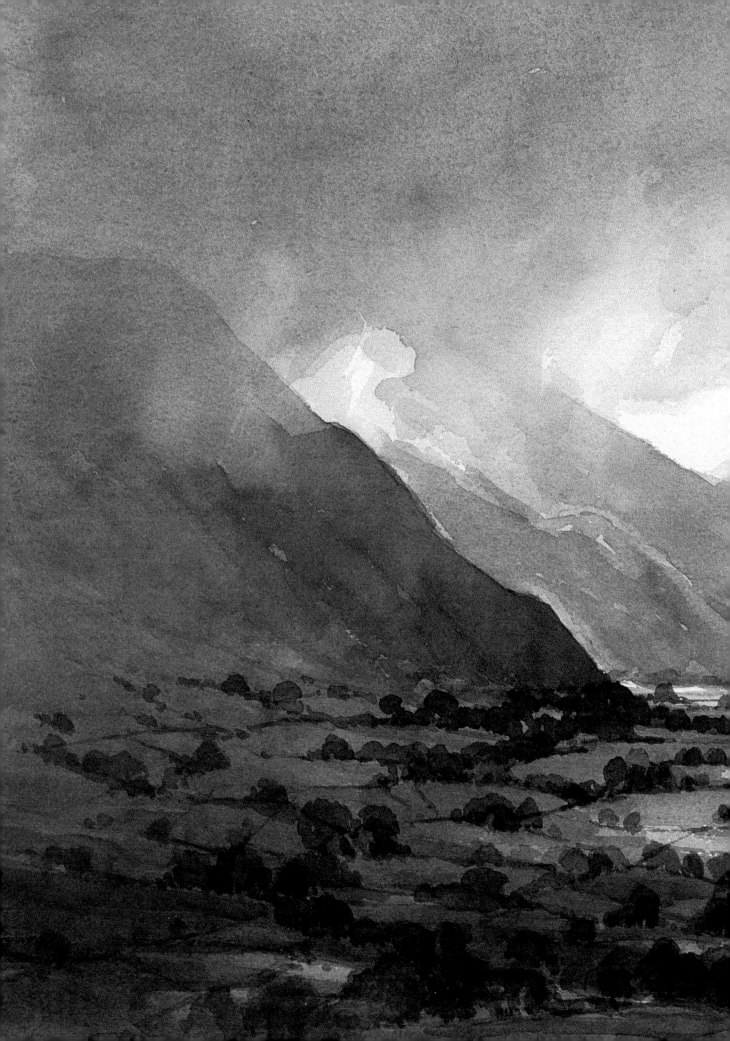

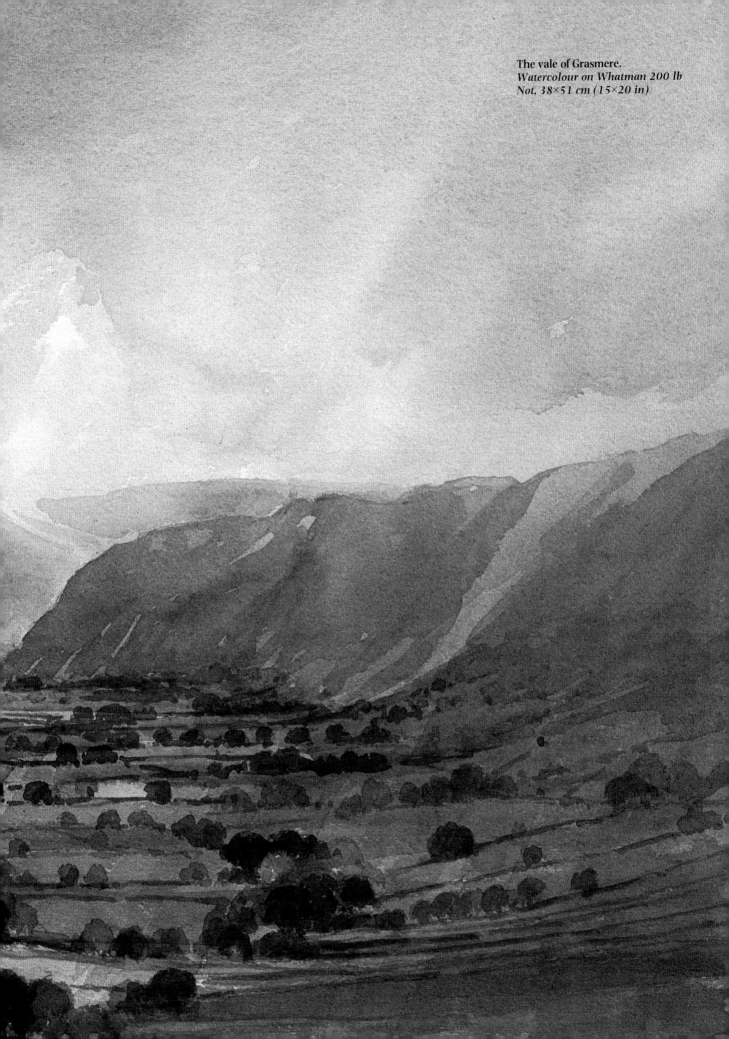

The vale of Grasmere.
*Watercolour on Whatman 200 lb
Not, 38×51 cm (15×20 in)*

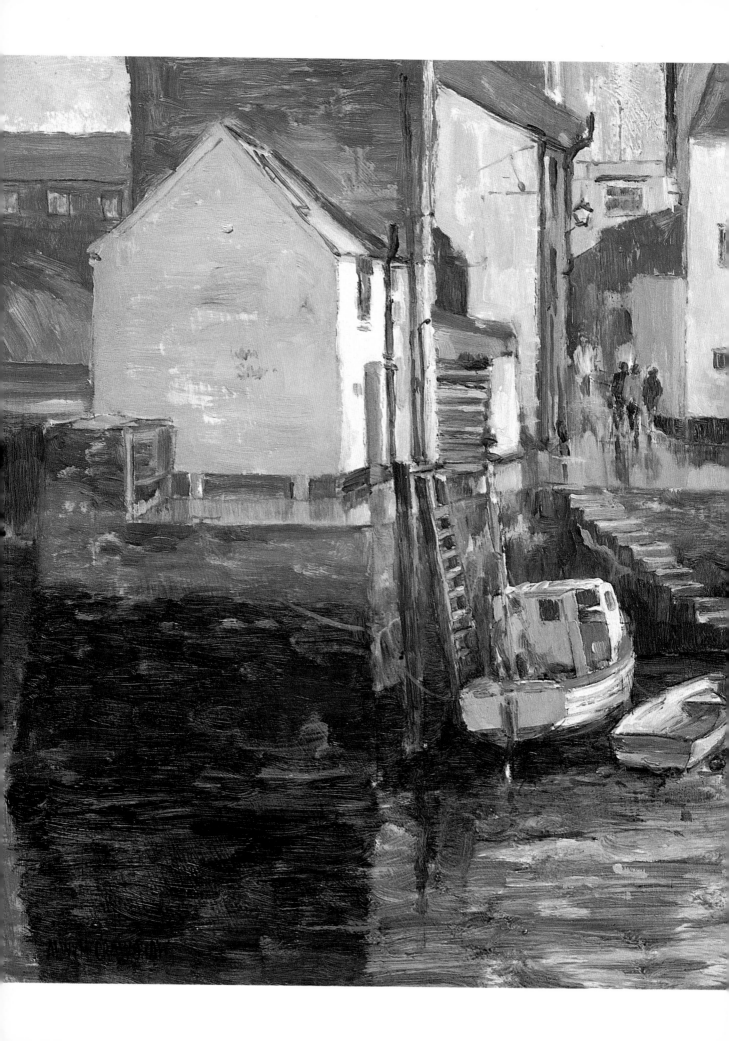

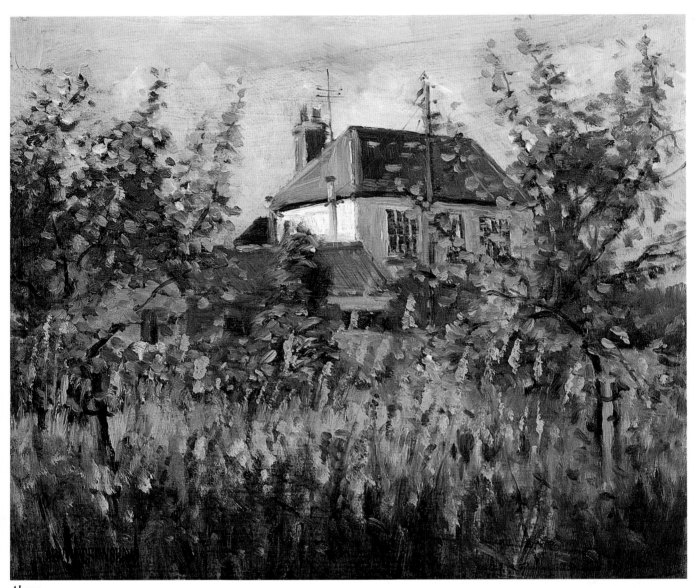

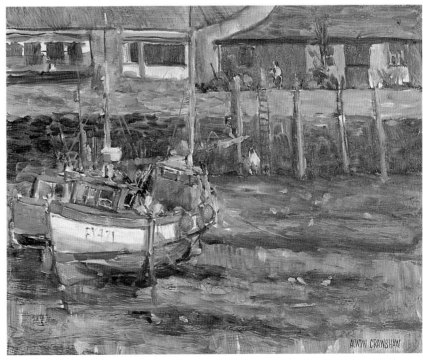

Above
From a corner of my garden.
Oil on hardboard, 25×30 cm (10×12 in)

Opposite
Polperro, Cornwall. *Oil on hardboard, 30×25 cm (12×10 in)*

Right
Fishing boat, Polperro. *Oil on hardboard, 25×30 cm (10×12 in)*

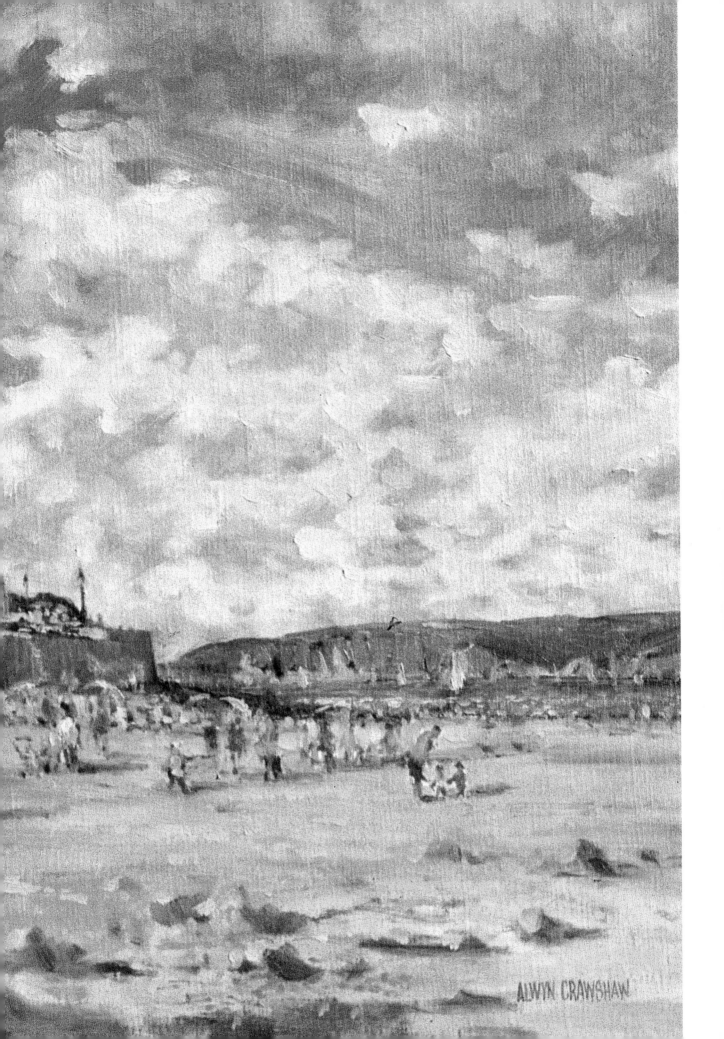

ALWYN CRAWSHAW

Early April sun, Whitby. *Oil on canvas, 41×51 cm (16×20 in)*